IMAGES
of America

THE 1936–1937
GREAT LAKES EXPOSITION

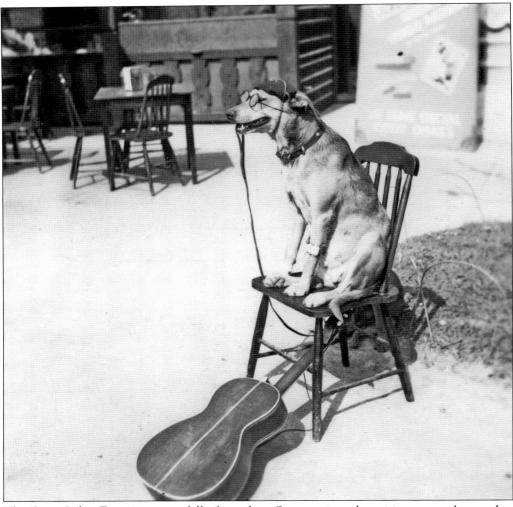

The Great Lakes Exposition was full of wonders. On any given day, visitors never knew what magical, fascinating, or bizarre sight or sound they would see around the next corner of the Exposition's Midway, Amusement, or Streets of the World sections, or on the strolling paths. One could come upon a juggler, an acrobat, a singer, a dancer, a dinosaur, a submarine, a fine restaurant, or as shown here, a singing dog act. (Author's collection.)

ON THE COVER: One of the most striking architectural features of the Great Lakes Exposition was the Art Deco–styled Automotive Building, which was described at the time as being "ultra-modern American." The Automotive Building, seen in the background, featured displays from the nation's major automobile and truck manufacturers and included an exhibition of visions of future transportation innovations. (Author's collection.)

IMAGES
of America

THE 1936–1937
GREAT LAKES EXPOSITION

Brad Schwartz
Foreword by William C. Barrow

ARCADIA
PUBLISHING

Published by Arcadia Publishing
Charleston, South Carolina

Printed in the United States of America

Library of Congress Control Number: 2016937660

For all general information, please contact Arcadia Publishing:
Telephone 843-853-2070
Fax 843-853-0044
E-mail sales@arcadiapublishing.com
For customer service and orders:
Toll-Free 1-888-313-2665

Visit us on the Internet at www.arcadiapublishing.com

This book is dedicated to the creative, artistic, and athletic talents of my father, Edward J. Schwartz, and my children, Evan and Elli Schwartz.

CONTENTS

FOREWORD

Cleveland has always had a problem with its lakefront. Initially a ribbon of land at the bottom of a steep cliff, it quickly became the preferred route for a transcontinental railroad that further isolated the town from the lake. Decades of infill merely added more rail yards, docks, lawsuits, and burning landfills to the scene, not much alleviated by a sooty Lake View Park on the hillside. Looking enviously at Chicago's relationship to its lakefront, Cleveland has tried in recent decades to bridge its tracks and freeway to be truly a Great Lakes city. In 1936 and 1937, it briefly made that connection during the Great Lakes Exposition. Indeed, when the city more recently commissioned a Boston design firm to tackle the question of what to do about the lakefront; they reported that we would do well to study the Expo for ideas.

Here, Brad Schwartz does study the Expo and, aided by some of his father's wonderful photographs, shares that story with us in an illustrious addition to our library of local history works. I met Brad when he came back to Cleveland State University to research this book and discuss how the Cleveland Memory Project could preserve and share his father's images. And what great pictures they are! The addition of Brad's father's 180-plus photographs to the visual record more than doubles the number of unique images of the Great Lakes Exposition; but more importantly, these images provide a more intimate view of the Exposition's attractions and of those who came to see them. These newly available photographs give added depth to our understanding of what the Exposition was about, and we now have photographs that visually illustrate what until now we have only been able to illustrate in words.

The Cleveland State University Library's Special Collections unit, which I head, is home for millions of photographs about greater Cleveland and northeast Ohio, anchored by our huge Cleveland Press Collection. From these collections and those of many area partners, we host the award-winning Cleveland Memory Project, online at clevelandmemory.org, where we share the highlights of these images freely with the worldwide public.

Cleveland has come a long way in recent years to recapture some of the excitement on our lakefront that was started by the Great Lakes Exposition. Cleveland now has an exciting North Coast Harbor, anchored by the Rock and Roll Hall of Fame, which will soon be accessible via a sinuous pedestrian bridge across the tracks—once again linking the Mall to the lakefront, as it was during the Exposition.

Today, Brad Schwartz is our link to those days 80 years ago when Cleveland first had an exciting lakefront, so get comfortable and enjoy this terrific visit to the Great Lakes Exposition of 1936–1937.

—William C. Barrow

ACKNOWLEDGMENTS

I would like to acknowledge the artistic contributions of my father, Edward Schwartz, who, in the summer of 1936, as an 18-year-old recent graduate of Cleveland's James Ford Rhodes High School, took most of the photographs in this book. I am in debt to William Barrow, head of Special Collections at Cleveland State University's Michael Schwartz Library and the driving force behind the Cleveland Memory Project since its inception, for his assistance and guidance and for graciously agreeing to write the foreword to this book. The Cleveland Memory Project's broad scope of historical images can be accessed at clevelandmemory.org. I also wish to thank David Ford, who set me on the path of conceiving and writing this book. Finally, I thank my wife, Coleen, and my children, Evan and Elli, for their love and support.

Most of the images in this book are from my personal collection (Author's collection). Additional images appear courtesy of the Cleveland Memory Project at the Michael Schwartz Library, Cleveland State University (CMP), David Ford (Ford), and other sources as noted.

INTRODUCTION

The Great Lakes Exposition was held in Cleveland, Ohio, during the Great Depression summers of 1936 and 1937. The purpose of the Exposition was to commemorate the centennial of Cleveland's incorporation as a city in 1836 and to celebrate the industrial riches of the Great Lakes states. The Exposition was organized by a small group of Cleveland business leaders, who in just four months raised $1.1 million in loaned investments to develop the Exposition grounds. There was little time to pull the Exposition together, and in just 80 days, thousands of Cleveland's building trade workers and additional hundreds of men who were employed through the federal government's Works Progress Administration completed the work of installing utilities, paving roads and plazas, and constructing the Exposition's more than 150 buildings and features. During its first summer, the Exposition drew just under four million visitors; in its second summer, it drew another three-and-a-half million. The 1930s were the age of Expositions. Chicago staged the Century of Progress International Exposition from 1933–1934, San Diego had its California Pacific International Exposition from 1935–1936, Dallas hosted the Texas Centennial Exposition in 1936, San Francisco staged the Golden Gate International Exposition from 1939–1940, and New York hosted the New York World's Fair from 1939–1940.

June 1936 proved to be a busy month in Cleveland. Long before the Expo's organizers conceived their plan to open their grand show on June 27, the city had committed to hosting the 1936 Republican National Convention from June 9–12. A few weeks before the Exposition opened, Cleveland hosted the convention that nominated Alfred Landon and Frank Knox to be the Republican presidential and vice presidential candidates.

The Great Lakes Exposition occupied a 135-acre site in Cleveland's downtown core and along its lakefront. Much of this land was vacant because it had been intended to house Cleveland's Great Mall that was envisioned by city planner Daniel Burnham. Additional land was made up from derelict parcels along Cleveland's Lake Erie shoreline that were home to a desperate army of Depression-era homeless men. In addition to these downtown and lakeshore properties, the Exposition was lucky to be granted the use of $40 million worth of Cleveland's existing building and land assets.

A historical plus for the city was that for the duration of the Exposition—and for the first time in its history—Cleveland's downtown and its lakefront were linked by a wooden causeway built over a railroad frontage that had separated them for more than 50 years. Only a few of the more than 150 buildings that were constructed for the Exposition were meant to be permanent; 80 years after the Expo's two-year run, nothing of the Exposition remains. The Great Lakes Science Center, the Rock and Roll Hall of Fame, the Cleveland Browns' First Energy Field, and Burke Lakefront Airport now occupy the same land where the Exposition stood during the summers of 1936 and 1937.

Visitors to the Expo entered the grounds by passing under 77-foot-tall pylons that would become the Expo's iconic image. Visitors then moved through the Sherwin-Williams Plaza and the Court of the Great Lakes. Cleveland's Public Hall, where the Republican National Convention was held, was adjacent to the plaza, and during the Expo, it was home to the world's largest radio

broadcasting studio. From an overlook at the north end of the court, Exposition visitors got their first view of the lower portions of the grounds. The Avenue of the Presidents, which occupied the wooden causeway that spanned Cleveland's railway system, was bordered by sixteen 16-foot-high pillars that were topped by 16-foot-high gilded eagles. Each pillar had a plaque that honored a US president who was either born in or elected from a Great Lakes state. The avenue also housed 100 booths on its east and west edges where visitors could buy food and souvenirs.

At the northern end of the causeway was the Standard Drug Building. Here, the Avenue of the Presidents transitioned to the Marine Plaza. The Marine Plaza had a broad grassy infield bordered by tall masts with lighted "crow's nests" and lines of colorful flags. The plaza's attractions included the Hall of Progress, where the epic production "Parade of the Years" was staged; the Automotive Building, in which the most impressive automotive industry advancements were displayed; the Hall of Progress, where exhibits of public service and other industries were presented; the Enamel Building, which housed displays of the most advanced technologies that existed at the time; and Cleveland's Municipal Stadium, where a stunning variety of professional and amateur athletic events were offered.

To the west on the plaza, visitors could see the only two of the Expo's features that were meant to be permanent additions to Cleveland's lakefront—the nautical-themed Horticulture Building and the 1,000-foot-long Horticultural Gardens. Also to the west were a floating New York–style nightclub and a large hillside floral depiction of the Exposition's logo. To the east on the Marine Plaza were the ultra-modern Art Deco–styled Transportation Building, the Firestone Building, and the Singing Fountains.

Exposition visitors then continued to the east, where they encountered the Expo's Amusement and Midway sections. The images in this book attest that the attractions in these sections reflected both the good and bad aspects of the culture of 1930s America. In the Amusement section, visitors could have their photograph taken (still a rare event for most people in the 1930s), see a circus, watch a Shakespearian play, or tour Adm. Richard E. Byrd's polar expedition ship, the *City of New York*. They could also descend into a World War I submarine, catch a fish dinner in an elevated pond, dance, go for a motorboat ride on the lake, ride over the Expo in a blimp, or watch a fireworks display. In addition to these tamer features, the Midway also offered entertainment that would be socially inappropriate in today's world.

At the east end of the Midway, visitors encountered the castle-like entrance to the Expo's Streets of the World (SOTW) section. This section celebrated the cultures, crafts, music, dance, and food of nearly 40 countries. Unfortunately, in a nod to the success of similar attractions at the nation's previous Expositions, many of the SOTW section's attractions also featured female nudity.

Because the Exposition did not meet its financial goals during the first summer, the decision was made to reopen it the following summer. When the Expo reopened at the end of May 1937, its monumental main entrance on St. Clair Avenue had been replaced by a smaller entrance on Lakeside Avenue, and some of its financially less-successful and less socially-appropriate attractions were replaced by larger, more phenomenal, and more appropriate features. One of the 1937 additions was a huge floating stage and a lake-water pool that featured Billy Rose's Aquacade, a music, dance, and swimming show that starred Johnny Weissmuller of *Tarzan* fame, and Olympic gold medalist Eleanor Holm. Although it was forbidden by Exposition organizers during the second year, a few of the Expo's 1937 attractions tried off and on to draw people in by offering female nudity, but their efforts were quickly checked.

A total of 112 of the images in this book are photographs that were taken by the author's father, Edward Schwartz, in August 1936. Some of his photographs highlight the Exposition's architecture and grandeur that were captured by other photographers, but he also produced images that show the grittiness and desperation of the Great Depression. He took more than 180 photographs of the Exposition, shooting 120-format film with a Rolleiflex camera, and made a single set of contact prints, which he gathered into a three-by-six-inch leather-bound book that he titled *Exposition Views—1936—Cleveland Ohio*. It is through the preservation of that little book that we are able to see these images 80 years later for the first time.

Attending the Exposition required a financial commitment, especially in the middle of the Great Depression. As seen in the photographs in this book, nearly all of the Exposition's attendees were well-dressed Caucasians. Partly because it was the 1930s, and partly because the Exposition was an "event," the dress code was summer dresses and heels for women and jackets and ties for men. There were very few children in attendance, especially during its first year, when nudity and questionable entertainment abounded. Nearly all of the Expo's attractions required a separate entrance fee of between 15¢ to see the Monkey Circus on the Midway to $3 to ride in a Goodyear blimp over the Exposition grounds and downtown Cleveland. Depending on how much one chose to do and eat and how many souvenirs to buy, the cost for one day at the Expo could range from $6 to $15, equal to $100 to $250 in today's dollars—about the cost of a one-day ticket at Walt Disney World.

While Cleveland's Great Lakes Exposition was not a financial success, the Expo drew positive national attention to an industrial city that had been ravaged by the disinvestment and crime that accompanied the Great Depression, and Cleveland showed that it could rise up and meet its challenges.

The legacy of the Great Lakes Exposition and the site on which it was held is a mixed one. Even after an additional year of operation, investors received back only half of their loaned investments. The summer of 1936 was abnormally hot, the abundance of nudity at many of the attractions and the price of admission kept families and the less-wealthy away, and the Expo did not draw many repeat visitors—all factors that negatively affected revenues.

As for the world in the mid-1930s, change was everywhere, and political tensions were high. The winter and summer Olympics were both held in Germany, the Hoover Dam was completed, Nazi Germany violated international treaties and reoccupied the Rhineland, Richard Hauptman was executed after being convicted of the Lindbergh kidnapping in 1932, Italian military forces occupied Ethiopia, a major heat wave brought widespread death to North America and reduced Exposition attendance, *Gone With the Wind* was published, the first fully controllable helicopter made its maiden voyage, the Spanish Civil War commenced, the British Broadcasting Corporation launched the world's first viable television broadcasts, Franklin Roosevelt was reelected to a second term as president of the United States, the first edition of *Life* magazine was published, Edward VIII abdicated the English throne, and—a few years after the Exposition closed its gates—the world was at war.

As for the site, nothing of the Exposition remains. The two features that were intended to be permanent additions to the city's lakefront did not last. The Horticulture Building burned down in the early 1940s, and the Horticultural Gardens waned until they were removed to make way for the Cleveland Browns' new stadium, FirstEnergy Stadium. After 80 years, the site thrives. Burnham's Great Mall has been realized, and in addition to the new stadium, the Expo's lakefront parcels are now occupied by FirstEnergy Stadium, the Rock and Roll Hall of Fame and Museum, the Great Lakes Science Center, and Burke Lakefront Airport. After all this time, though, there still is little pedestrian access between Cleveland's downtown and its lakefront attractions. This is scheduled to change with the construction of a pedestrian bridge that will stretch from the Great Mall to a lakefront site between the Rock and Roll Hall of Fame and the Great Lakes Science Center. Eighty-one years after the wooden causeway on which the Avenue of the Presidents stood spanned the railway system that had separated Cleveland from its lakefront, Clevelanders will once again be able to walk from their Great Mall to their now-great lakefront.

This book provides a visual tour of the 1936–1937 Great Lakes Exposition, and is organized to guide readers through the Expo from its main entrance on St. Clair Avenue through the seven major sections. A copy of the Exposition's souvenir map is included on pages 28 and 29 for reference during this visual tour.

Enjoy the wonder and spectacle that is contained in the images in this book, and experience the grand time that was had by visitors to Cleveland's 1936–1937 Great Lakes Exposition.

One

A Grand Plan

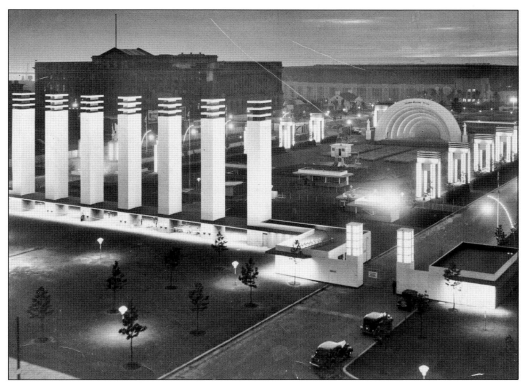

The Great Lakes Exposition was heavily advertised throughout the Great Lakes region leading up to its opening on June 27, 1936. Despite the economic stresses of the Great Depression, the organizers' goal of attracting seven million visitors was reached by the end of the Expo's second summer. Originally scheduled to run for 100 days in the summer of 1936, the Exposition was continued into a second summer to try to break even financially. This dramatic nighttime photograph of the Exposition's main entrance illustrates the grandeur that the organizers hoped to convey to the world. (CMP.)

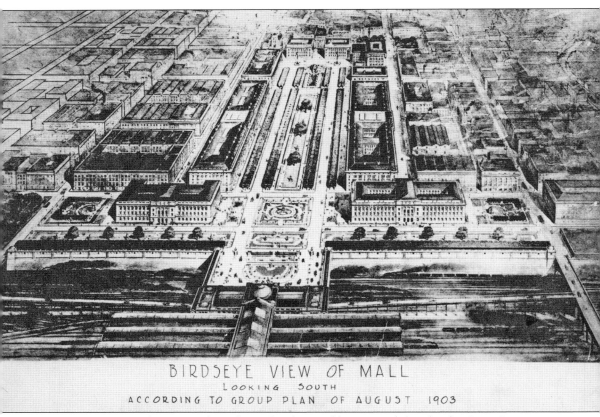

BIRDSEYE VIEW OF MALL
LOOKING SOUTH
ACCORDING TO GROUP PLAN OF AUGUST 1903

Due to economic downturns brought on first by World War I and then by the Great Depression, Daniel Burnham's 1903 Group Plan for the Mall in Cleveland's downtown core had only been partially completed by the mid-1930s. Exposition organizers took advantage of the resulting expanse of undeveloped space in the city's downtown core as an ideal location to house the upper portions of the Great Lakes Exposition grounds. Linking this area with expanses of land along the Lake Erie shoreline resulted in a 153-acre footprint for the Exposition. Seen here, Burnham's conceptual sketch shows a mall capped by a grand Union Terminal to service the expanse of railroad lines along the Lake Erie shoreline (at the bottom of this illustration). Burnham's proposal for a Union Terminal along the shoreline was made obsolete by the construction of Cleveland's iconic Terminal Tower in 1927, which served as the city's primary railroad terminal. (CMP.)

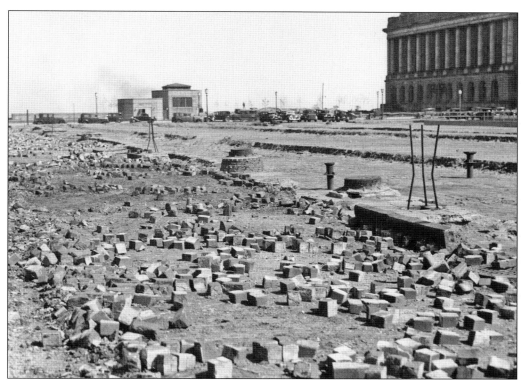

These two images show how portions of the area that had been set aside for the development of Cleveland's Great Mall looked at the height of the Great Depression in 1934 (above) and in 1932 (right). In each of these images, the Mall area is an undeveloped, rubble-filled field. It is easy to see why the idea of using the Mall area to house the upper portions of the Great Lakes Exposition was so attractive to the City of Cleveland. While development of the Great Mall would continue off-and-on through the years, it would be many decades before Burnham's plan was fully realized. (Both, CMP.)

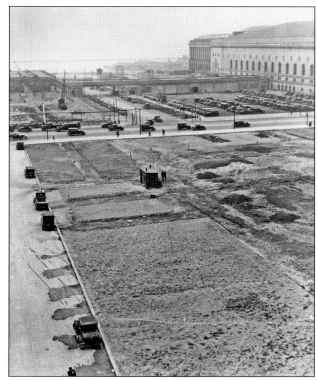

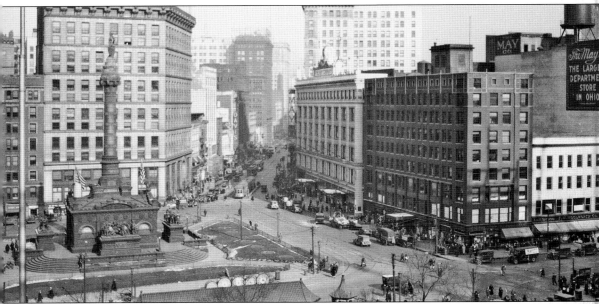

This photograph, taken about 10 years before the Exposition opened, shows the active character of Cleveland's Public Square area in pre-Depression years. The view looks east across the Public Square to Cleveland's main street, Euclid Avenue, and the Soldiers and Sailors Monument, which was dedicated by Pres. William McKinley in 1894. At the time of its construction in 1927, Terminal Tower, which was behind the photographer, was the third-tallest building in the world. The two buildings directly behind the monument at left, the Cuyahoga Building and the Williamson Building, were imploded in 1982 and replaced by the Key Bank building, which took the Terminal Tower's place as Cleveland's tallest building. At the time of this photograph, the May Company building (the large building at right) was Ohio's largest department store. (Author's collection.)

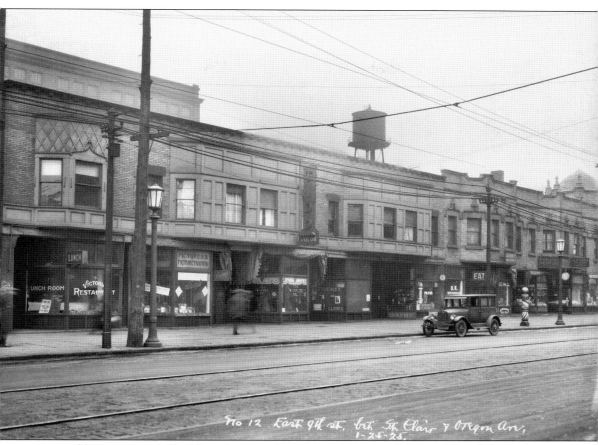

Pictured here are a set of buildings between St. Clair and Oregon Avenues. This photograph is one in a series of 75 that were taken in 1925 to document buildings that existed prior to the start of a post–World War I plan to continue work on the development of the portion of Cleveland's downtown core that was identified in Daniel Burnham's 1903 Group Plan. Cleveland's second effort for the development of Burnham's plan was halted at the start of the Great Depression, just four years after these photographs were taken. In 1936, at the opening of the Exposition, many parcels that were in and around the Group Plan's designated area were undeveloped or under-developed. Eleven years after this picture was taken, these buildings would be at the north end of the Exposition's main entrance. A dozen businesses occupied the storefronts on this one block. (Author's collection.)

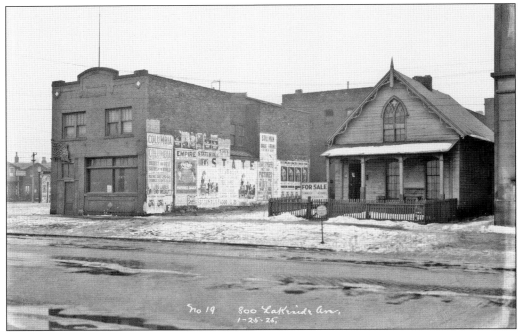

These two images from the 1925 photographic parcel survey show what existed in the 800 block of Lakeside Avenue and the 300 block of East Third Street at that time. In 1936, the 800 block of Lakeside Avenue would be just west of the Exposition's main entrance, and the 300 block of East Third Street would be just east of Sherwin-Williams Plaza. Like most large cities that were based on a manufacturing economy, the advent of World War I, followed by the Great Depression a decade later, resulted in considerable disinvestment in public works projects, and delays in the construction of nonessential development projects. (Both, author's collection.)

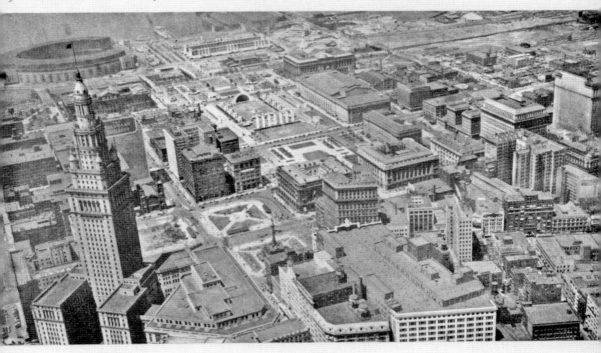

The progress of the development of Burnham's Group Plan (top center) can be seen in this aerial photograph of downtown Cleveland that was taken during the Exposition. By the start of the Exposition, construction of Cleveland City Hall, Public Hall, Public Library, the post office, and the Cuyahoga County Courthouse had been completed. Terminal Tower (lower left) was completed in 1927, but was not included in Burnham's plan. In this image, the Exposition covers the lighter portion at top center. During the Exposition, the area that was to become the Great Mall housed the main entrance, Sherwin-Williams Plaza, and the Court of the Great Lakes. Thousands of Cleveland's trade workers were employed to construct the Exposition's buildings and grounds, and hundreds more were employed through the federal government's Works Progress Administration in the spring of 1936. (CMP.)

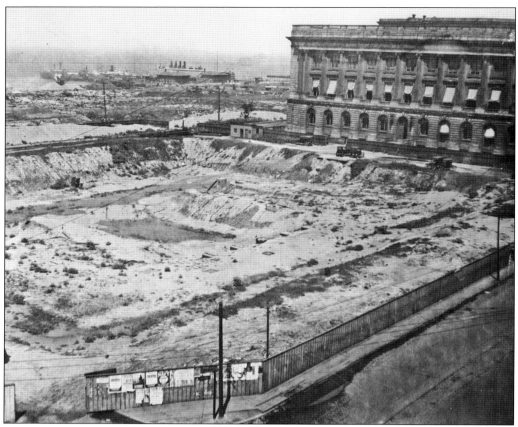

In these 1925 photographs, Cuyahoga County's fifth courthouse building is shown with a large excavation to its west. This was intended to be the site of a new jail building, but no structure was ever erected there. The fifth courthouse is still in use today and houses some judicial functions, including the Court of Appeals, Probate Court, and the Domestic Relations Court. The site of this hole in the ground at the corner of West Third Street and West Lakeside Avenue is now Fort Huntington Park. (Above, CMP; below, author's collection.)

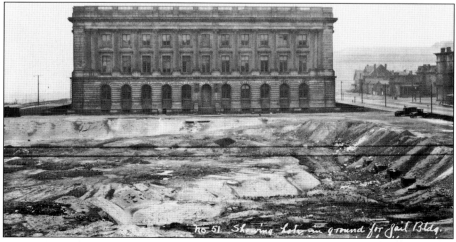

Above, Cleveland's Public Hall is visible to the right, and City Hall is at left in the distance behind the cottage-industry machining company building in the foreground. This is a good example of the effect that two decades of disinvestment had on Cleveland's infrastructure. Note the curbside gas pump at left. The Acme Restaurant and Quick Lunch, shown below, which was next to Public Hall, was on the piece of land where the Exposition's main entrance would be 11 years later. Given Cleveland's lack of investment during the two decades prior to the opening of the Exposition in 1936, it is possible that this building remained in this spot until it was removed to make way for construction of the Expo's entrance. (Both, author's collection.)

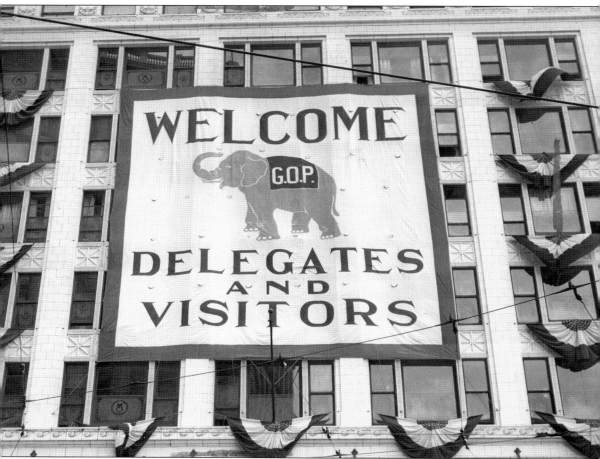

From June 9 to 12, just 15 days before the opening of the Great Lakes Exposition, Cleveland hosted the 1936 Republican Convention. Here, a three-story banner welcoming convention delegates hangs from the side of the downtown May Company department store. The Republican convention nominated Alfred Landon of Kansas as its presidential candidate. Landon lost the general election in November to Franklin D. Roosevelt, who would begin his second of four terms as president of the United States in January 1937. Franklin and Eleanor Roosevelt were guests of the Great Lakes Exposition in June 1936, and stayed in staterooms aboard the S.S. *Moses Cleaveland*, a great lakes transport ship that had been fitted out as the Showboat entertainment facility for the duration of the Exposition. The Showboat included a New York–style nightclub, a luxury dining facility, and luxury staterooms. (CMP.)

Great expanses of open land along Cleveland's lakefront housed the Exposition's Horticulture Building and Gardens, the Marine Plaza, the Amusement and Midway sections, the Streets of the World feature, the Military Encampment, and the Goodyear blimp grounds. While it was reported that the Expo attracted nearly four million visitors in its first year, revenues were not as large as expected, and it was decided that in order to be able to pay back investors, the Exposition would be continued into a second year. Investors eventually received only half of their investments back at the end of the second summer. (Above, CMP; below, author's collection.)

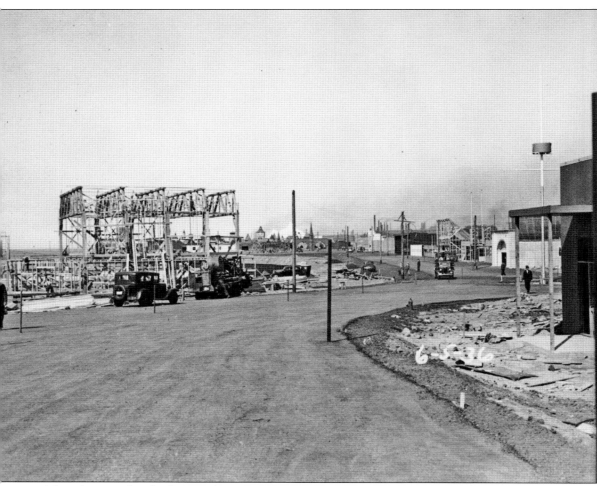

This photograph, which was taken on June 5, 1936, just three weeks before the opening of the Great Lakes Exposition, shows construction at the northern end of what would be Marine Plaza, at its intersection with the entrance to the Midway. All of the Exposition's buildings, roads, and utilities were constructed and installed in just 80 days. Many of the features in the Streets of the World section, visible in the background, were either already completed or were in progress at this time. Three prominent features include the double-arched entrance; one of the towers from the reproduction of Krakow, Poland's St. Mary's Cathedral; and the Matterhorn, which is the white mountain feature at center background. (CMP.)

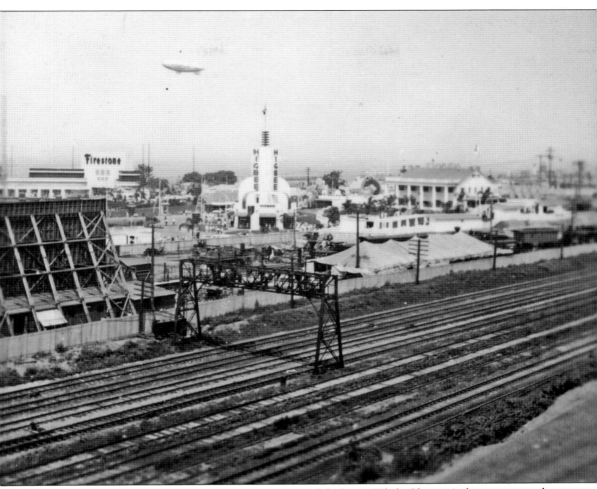

Cleveland had always looked enviously at Chicago's lakefront. While Chicago's shore runs north-south along Lake Michigan, Cleveland's lakefront runs east-west along Lake Erie. When the nation's system of transcontinental rail lines was developed in the late 1800s, it ran east-west along Cleveland's lakeshore and blocked the connection between downtown and lakefront properties. Chicago was fortunate that those same rail lines passed to the south of the city and did not affect its lakeshore connections. This image offers a good representation of what Cleveland's lakeshore properties looked like before the Exposition's development. Generally, these properties were derelict and occupied by a combination of trash dumps, industrial infrastructure, and the makeshift shacks of Depression-era homeless. Unfortunately, the connection that was made between Cleveland's downtown and its lakeshore properties during the Exposition was only temporary, and when the causeway that made that connection was demolished after the 1937 season, Cleveland's homeless returned and took possession of these properties once again. (Author's collection.)

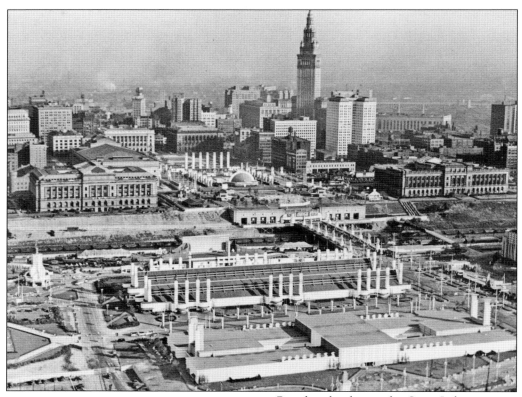

Based on land area, the Great Lakes Exposition was one of the largest of the nation's 1930s Expositions. Still, when viewed from overhead, as in the image above that looks east toward the downtown area, the 153-acre site looks compact. The Exposition's buildings and attractions were strategically located and constructed to provide visitors with ever-changing vistas and visual separation from other features as they moved through the grounds. By doing this, the grounds appeared to visitors to be much larger than they really were. The grounds stretched from two blocks northeast of Public Square to the intersection of East Twentieth Street and the lakeshore. Each of the Exposition's sections had its own character, which was established through visual cues such as the Avenue of the Presidents' commemorative pillars, the Marine Plaza's crow's nest–topped and flag-draped masts (as shown at left), the Midway's ship's wheels, and the Streets of the Worlds' villages and varied architectural styles. (Above, CMP; left, author's collection.)

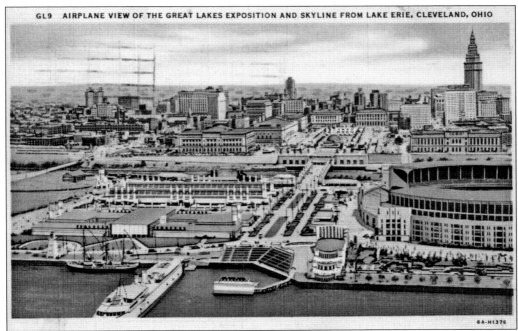

6A-H1376

These two aerial views of the Exposition, looking from the lake to the southwest (above) and the southeast (below), show the relationship between the Expo and downtown. The image above features the Firestone and the Automotive Buildings (bottom), the Avenue of the Presidents on the wooden causeway over the lakeshore rail lines (center right), the Sherwin-Williams Plaza and Court of the Great Lakes, the main entrance (center left), and Terminal Tower (top). The lower image shows additional features along the lakefront, including, from left to right, Admiral Byrd's Antarctic expedition ship *City of New York*, the Showboat entertainment attraction; the Marine Amphitheater; and the Horticulture Building. (Both, CMP.)

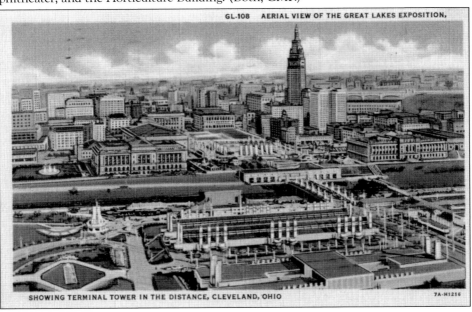

GL-108 AERIAL VIEW OF THE GREAT LAKES EXPOSITION,

SHOWING TERMINAL TOWER IN THE DISTANCE, CLEVELAND, OHIO 7A-H1216

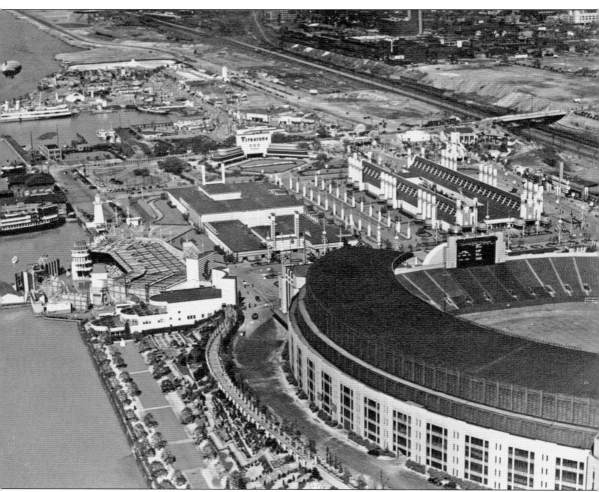

This photograph looks east from Municipal Stadium and shows (from bottom to top) the Automotive and Firestone Buildings, the Amusement and Midway sections, the Streets of the World, and the blimp grounds. Before the development of the Exposition grounds in the mid-1930s, all of this land along the lakefront remained undeveloped, and during the Depression years, it was taken over by Cleveland's army of unemployed and homeless men. During the Depression, this "city" along the lakefront was one of many around the nation known as "Hooverville," named after Pres. Herbert Hoover, who many blamed for not effectively addressing the economic conditions that brought about the Great Depression. Thousands of men and their makeshift dwellings were eliminated from the lakefront properties to make way for the development of the Exposition grounds. (CMP.)

The author's father, Edward Schwartz, took many of the photographs in this book in August 1936, shooting 120-format film with a Rolleiflex camera. He is pictured in the c. 1940 photograph at right holding a portrait camera and standing outside a shelter house in a Cleveland park. Schwartz captured 187 unique images of the Exposition and printed them only once, in the leather-bound book pictured below. A total of 111 of his Exposition photographs are being published for the first time in this book. Also pictured below is a souvenir that he purchased at the 1936 Great Lakes Exposition: a pair of hand-carved wooden shoes made by Belgian carver John Vrombaut, who worked in a workshop in the Belgian Village section of the Exposition's Streets of the World section. Also pictured is the photographer's Exposure meter, which he used while taking these photographs. (Both, author's collection.)

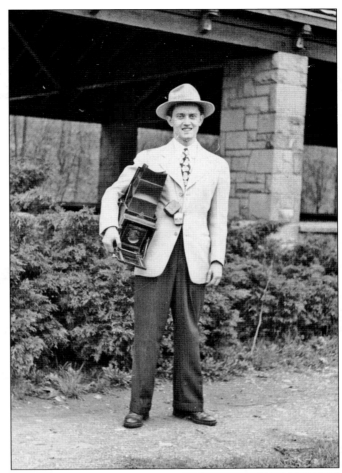

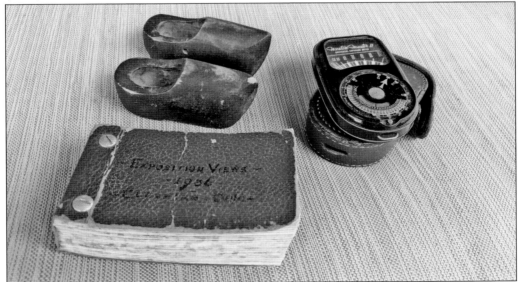

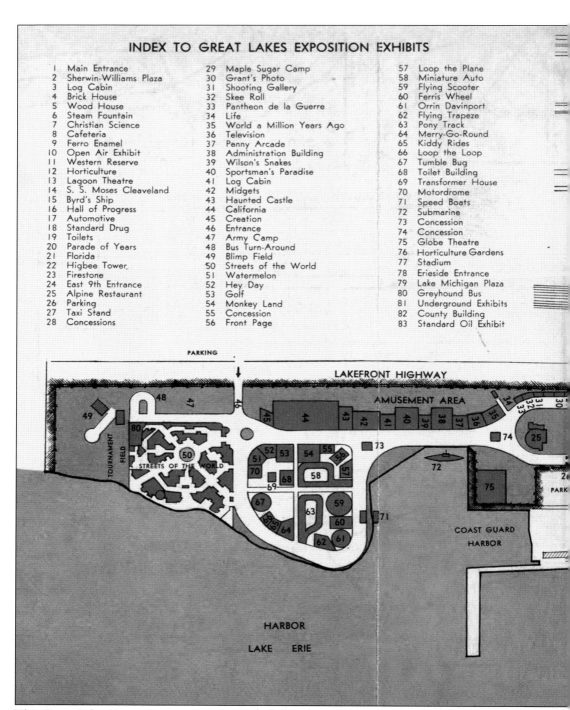

INDEX TO GREAT LAKES EXPOSITION EXHIBITS

This Great Lakes Exposition site map was included in the souvenir guidebook that was available for purchase at the entry gates. The map identifies the location of the Expo's features and exhibits. This map serves as a good illustration of how the Expo's upper section (main entrance, Sherwin-Williams Plaza, and Court of the Great Lakes) and its lower sections (Municipal Stadium,

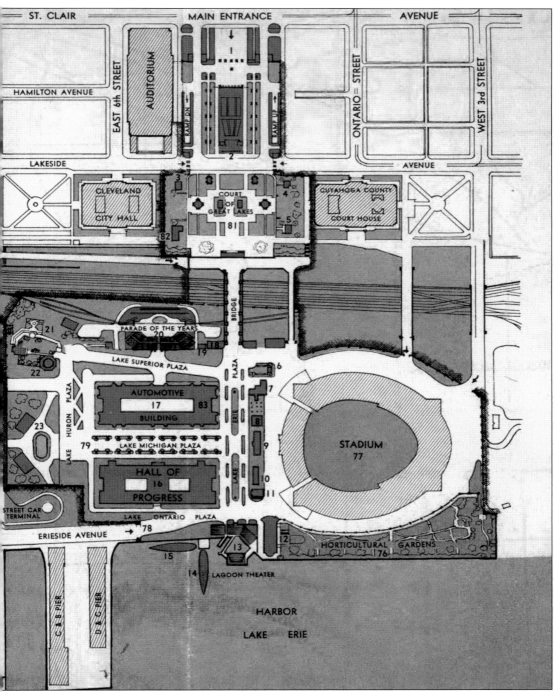

Automotive Building, Marine Plaza, Amusement and Midway, Streets of the World, and the blimp grounds), were connected by the wooden causeway over the lakeshore rail lines, on which the Avenue of the Presidents was located. This map can be used as a reference by the reader on the way through this book's photographic tour. (CMP.)

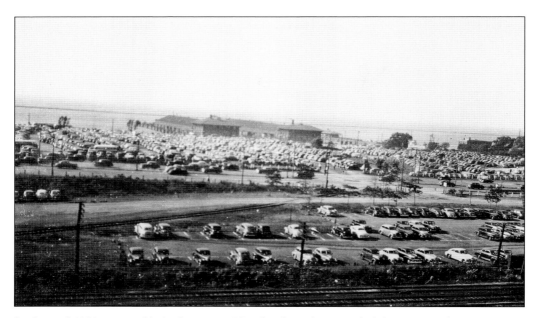

In the mid-1930s, it was likely that more Clevelanders who attended the Great Lakes Exposition arrived to the site by streetcar than by automobile. For those who did travel to the Exposition by automobile, parking was plentiful. Although they were mostly unimproved lots, parking areas were available in the area that is now Cleveland's Shoreway Drive and in other areas near the Exposition grounds. Parking was also available along downtown streets. The image above shows one of the designated parking areas filled with cars. The image below shows a season parking pass that most likely was used by a vendor or an exhibitor. (Above, CMP; below, Ford.)

Two

A Grand Entrance

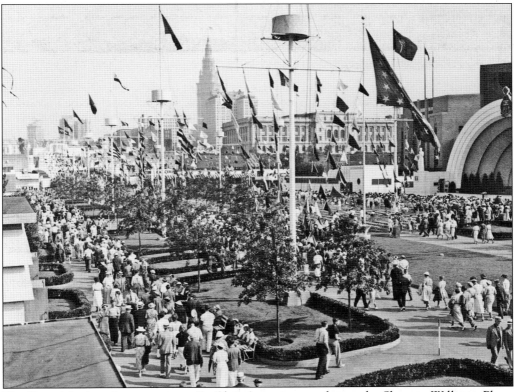

The Exposition's main entrance on St. Clair Avenue opened onto the Sherwin-Williams Plaza, which featured the Sherwin-Williams Band Shell. Exposition visitors proceeded from here to the lushly landscaped Court of the Great Lakes, which housed reproductions of cabins of Ohio's historical figures, including the James Garfield cabin, model homes, and the Ohio Building. The original Garfield family cabin was erected in 1825 by Abram Garfield, the grandfather of another Abram Garfield who was the Exposition's supervising architect. Features of the Exposition and the city that can be seen in this image include the Court of the Great Lakes, which shared the same decorative lighting fixtures that were used on the Marine Plaza and took the form of ship's masts with colorful lines of flags attached. Other features are the Sherwin-Williams Band Shell (far right) and Terminal Tower (center background). (CMP.)

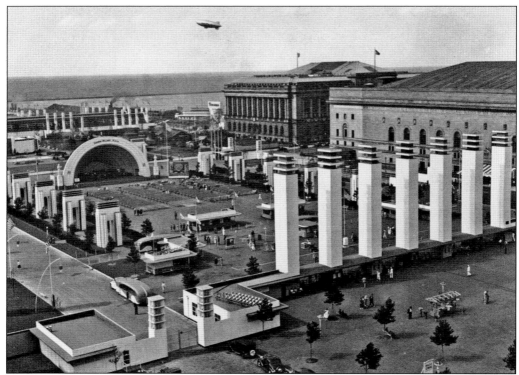

Exposition visitors were able to look down on the remainder of the grounds from the Ohio Building's rooftop terrace and from an overlook at the north end of the Court of the Great Lakes. Farther to the north was the Lakeside Exhibition Hall, where the "Romance of Iron and Steel" program was presented, and industrial displays showed how iron ore was extracted and iron and steel were manufactured. The Cleveland Public Auditorium, where the main events of the Republican National Convention were held only two weeks prior to the opening of the Exposition, and where the Exposition's Radioland attraction was located, was adjacent to the Sherwin-Williams Plaza and can be seen at right. (Both, CMP.)

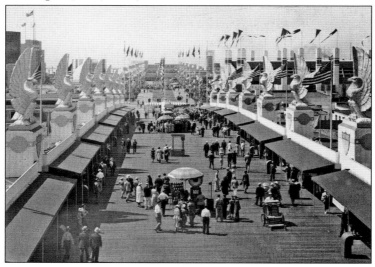

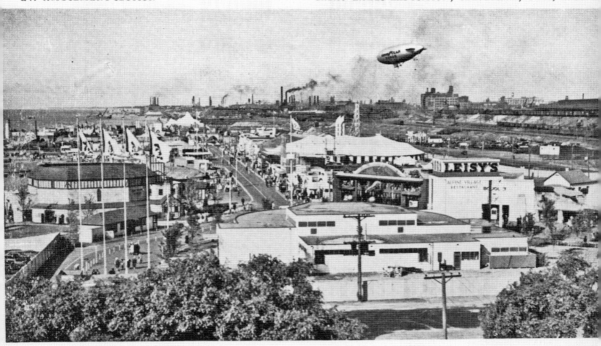

This image of the Exposition's Amusement section is premature in our tour, but it offers a glimpse of what Expo visitors would have had a distant view of as they looked to the north from the Court of the Great Lakes overlook. It might have been hard for some visitors to resist the temptation of racing over the causeway that joined the Expo's upper and lower sections and to make a mad dash to the east through the Marine Plaza to get to the more exciting attractions. There was more than a day's worth of entertainment offered at the Exposition, so visitors would have had to use their souvenir guide to decide what they were going to see and do. This elevated view to the east shows the juxtaposition of the Exposition's vitality against the backdrop of the grittiness of Cleveland industry. Eighty days before the Exposition opened in June 1936, most of this area was a wasteland, and after the Exposition closed for good in the fall of 1937, it reverted to its previous state. (Author's collection.)

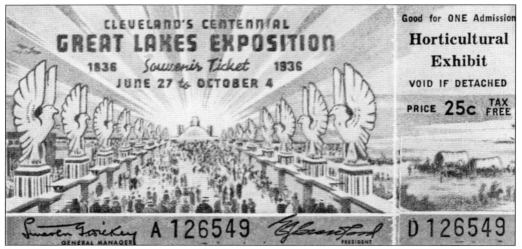

In addition to the main entrance on St. Clair Avenue, other entrances to the Exposition grounds were located at Lakeside Avenue between the Public Auditorium and City Hall; on Lakeside Avenue, just east of Ontario Street; a Lake Erie access for boat traffic at the northern end of East Ninth Street at the Lighthouse; on the Lakefront Highway near the Amusement section (where in the image below a group of White Motor Corporation employees and US Army personnel can be seen talking); and on West Third Street, near Municipal Stadium. Exposition visitors could buy individual tickets to the Expo's sections and attractions, or they could choose from a number of ticket book options that would provide them access to a number of sections and attractions. The image above shows a souvenir ticket book from the 1936 season that included admissions to a number of attractions. (Above, author's collection; below, Ford.)

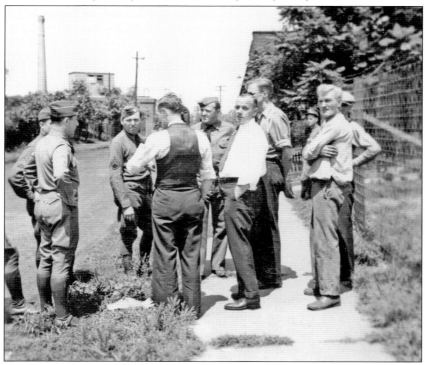

34

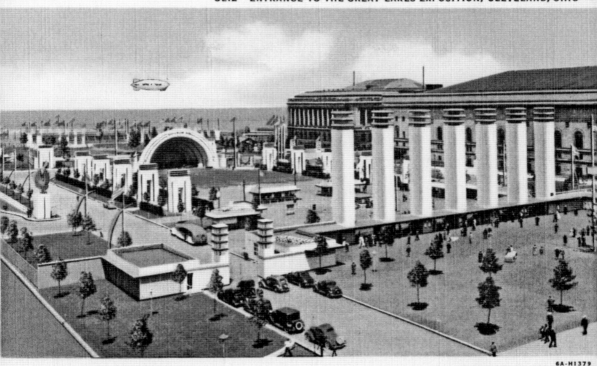

6A-H1379

The 77-foot-tall Art Deco–style pylons at the main entrance were the Exposition's signature image. Each of the gleaming white pylons was topped by a three-layered lighting fixture, which made them appear to be seven lighthouses that spread their light and welcomed the world to the Exposition grounds at night. The main entrance's pylons appeared on advertising posters and other artwork, such as tickets. Anthony Ciresi, who was an instructor at the Cleveland School of Architecture, designed the main entrance. Ciresi's design was chosen in a contest that was judged by the Exposition's architecture committee. The Exposition's grand opening was a well-orchestrated production. At noon on June 27, 1936, Pres. Franklin D. Roosevelt, at his desk in the Oval Office, pressed a button and remotely opened the Exposition's main gates. (CMP.)

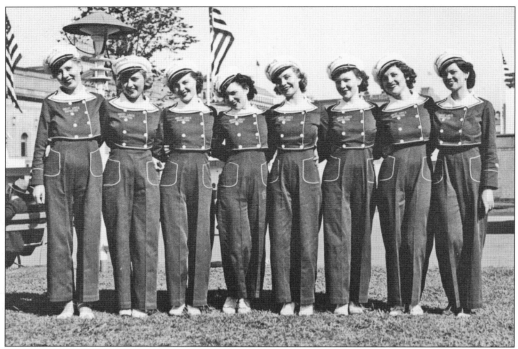

The Yeomanettes were the Exposition's official hostesses. Selected from across the state, Yeomanettes were chosen mainly for their beauty and poise. Dressed in nautical-styled uniforms and yachting caps, Yeomanettes spent their days walking about the Exposition grounds, talking with visitors, giving directions, and posing for pictures. The photograph above shows a line of eight Yeomanettes posing for a publicity picture. The image below shows Yeomanettes on Admiral Byrd's *City of New York*. Yeomanettes were just as omnipresent as the Exposition's transport buses and the Goodyear blimps. A close look will reveal Yeomanettes in other photographs in this book. (Both, CMP.)

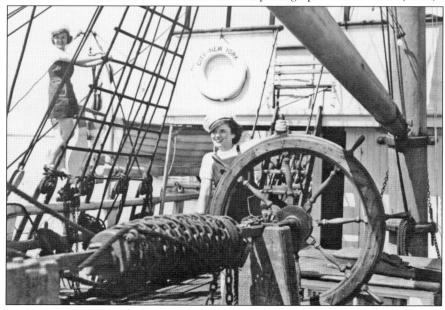

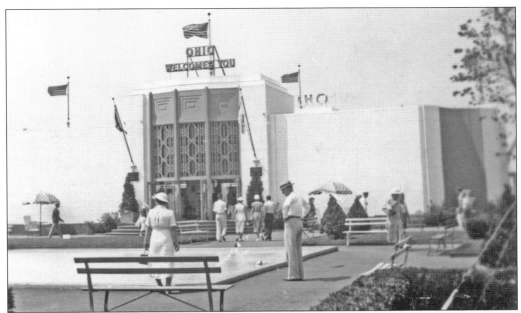

Pictured here is the south façade of the Ohio Building, with its reflecting pool. Inside were displays that highlighted the state's industrial, natural, and artistic resources, industries, and people. Construction of the Ohio Building had not started at the time of the Expo's opening at the end of June 1936 and would not be completed until the beginning of August, because funding for the building was held up in the state legislature by a few southern state representatives who questioned the value of spending state funds on a temporary building in Cleveland. Funding was eventually approved, and the building was erected while the Exposition was in progress. Below, the pure white façade of the Ohio Building can be seen peeking over the Coca-Cola sign at the southern end of the Avenue of the Presidents. The presence of the Ohio Building in these photographs helps determine when they were taken. (Both, author's collection.)

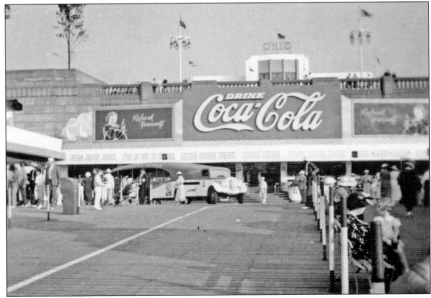

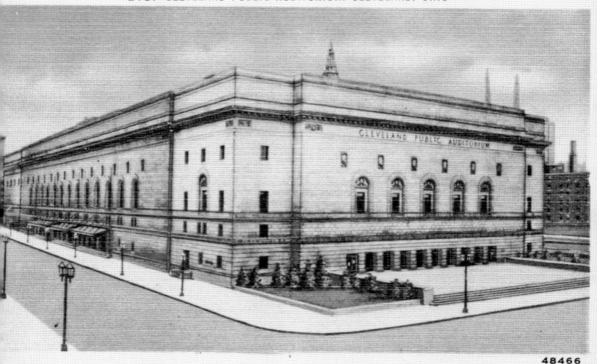

48466

Cleveland's Public Hall was part of the $40 million in public assets that the Exposition was given use of. Public Hall (seen here in the 1940s as the Public Auditorium) is located between St. Clair Avenue and Lakeside Avenue and flanked the eastern edge of the Exposition's Sherwin-Williams Plaza. A few weeks before the opening of the 1936 season, Public Hall hosted the Republican National Convention; during the Exposition, it housed Radioland, which was billed as the world's largest radio broadcasting studio. It was also the host of various educational and cultural exhibits by federal, state, and local governments that told the story of the Great Lakes states. One of the hall's largest and most interesting exhibits was a relief map of the city of Cleveland that was built by WPA workers. A novelty feature was a display sponsored by the Cleveland Police Department where visitors could have their fingerprints taken. (CMP.)

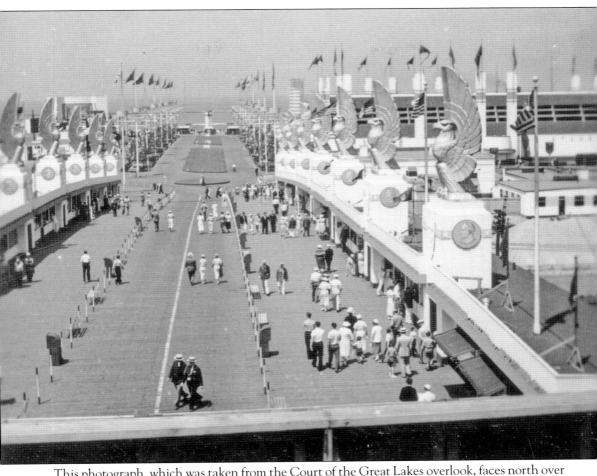

This photograph, which was taken from the Court of the Great Lakes overlook, faces north over the Avenue of the Presidents and toward the Lake Erie shoreline. The Avenue of the Presidents was built on an elevated wooden causeway that spanned the wide expanse of the lakeshore railway lines and connected the Exposition's upper and lower sections. More importantly, the causeway connected Cleveland's downtown with its lakeshore for the first time since the rail lines were built more than 50 years earlier. While the rail lines were important to Cleveland's commerce, they separated the city from another valuable resource—17 miles of lakeshore property. (Author's collection.)

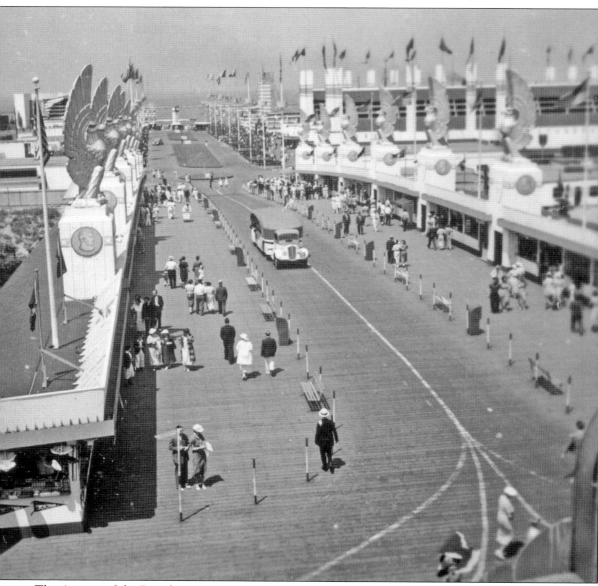

The Avenue of the Presidents was 100 feet wide and 350 feet long and lined on each side by 50 booths where Expo visitors could buy food and souvenirs. Each of the Court of the Presidents' enormous pillars honored one of the 16 presidents of the United States who were natives of, or elected from, one of the Great Lakes states. Each 16-foot-high pillar had large gilded medallions, one with the name of the president being honored and one that listed the president's major achievements and contributions to the nation. A 16-foot gilded eagle topped each pillar. In this image, Expo visitors can be seen walking along the avenue and browsing its food and souvenir stands. One of the Exposition's Greyhound transport buses can be seen driving down the center lane. (Author's collection.)

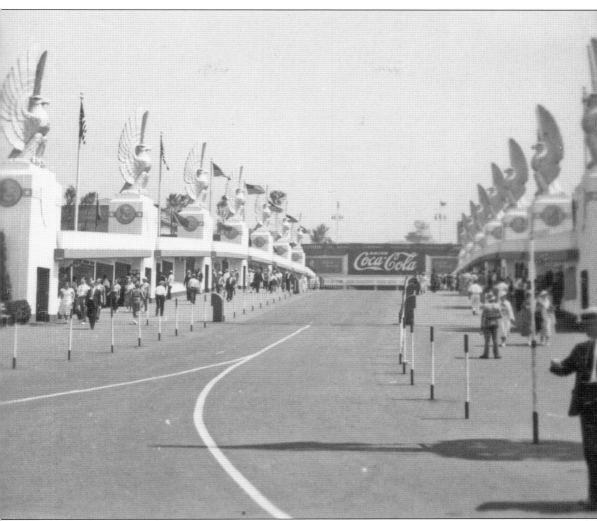

The majesty of the Avenue of the Presidents' 16-foot-tall gilded eagles is accentuated by the afternoon sun in this photograph that looks south back toward the Court of the Great Lakes. In addition to an eagle sculpture, each of the 16 pillars had a shield placard on the street side that indicated which Great Lakes president was being honored and a coin-like bas-relief medallion with the president's profile image and term of service. Two of the court's lantern-decked flagpoles and a sign-topped downtown Cleveland building can be seen above the Coca-Cola sign at the southern end of the avenue. Exposition visitors can be seen checking out the 100 souvenir and food stands that lined the avenue. The top of Public Hall can also be seen peeking out between the first and second pillars on the left. As can be seen in this image and others in this book, the Exposition grounds were kept meticulously clean. (Author's collection.)

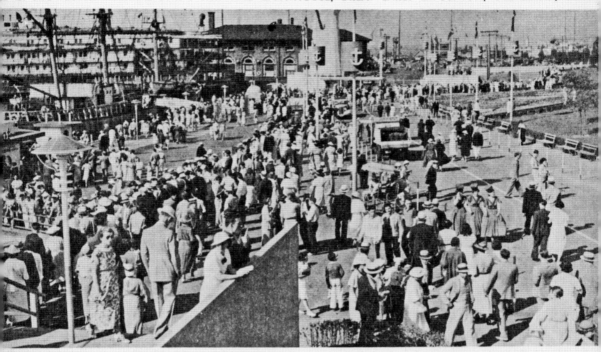

Although the Exposition did not draw the numbers of visitors that its organizers hoped and planned for, its grounds were often packed with people, as is evidenced by this image of crowds on the Expo's Marine Plaza. A close look at the people in this photograph is a telling lesson of the effect of the organizers' choices of attractions, the impact of the Great Depression, the cost of attending the Expo, and the racial divisions of the times on the demographics of attendees. Visitors were almost universally well dressed, affluent, and white. As mentioned in the introduction, depending on how many individually priced attractions an Expo visitor chose to take in, the one-day cost of attendance could range from $100 to $250 in today's money—a price that would have been out of reach for most Americans at the height of the Depression. Additionally, because of the amount of nudity that was featured at the Expo, there were very few children in attendance during the first year, and because many of the Expo's attractions barred them, very few African Americans attended either. (Author's collection.)

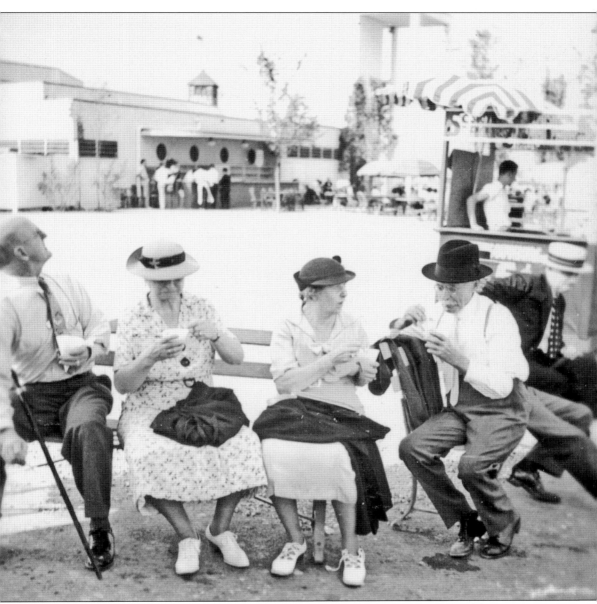

Visitors could choose from hundreds of places to purchase food and snacks. Food from 40 nations was available from handcarts, walk-up food stands, casual dining facilities, a central cafeteria, and fancier cantinas, restaurants, and nightclubs on the Midway and in the Streets of the World. In this photograph, four older visitors rest on benches while they eat a snack served in a paper cone. A stand offering souvenirs for 5¢ can be seen directly behind them. Elderly visitors to the Great Lakes Exposition must have been especially amazed at some of the technological innovations that were introduced, including television and the fluorescent light bulb. Cleveland's Nela Park research facility was one of the world's leaders in lighting innovation, and was instrumental in making sure that the Exposition was one of the best-lit locations in the world. (Author's collection.)

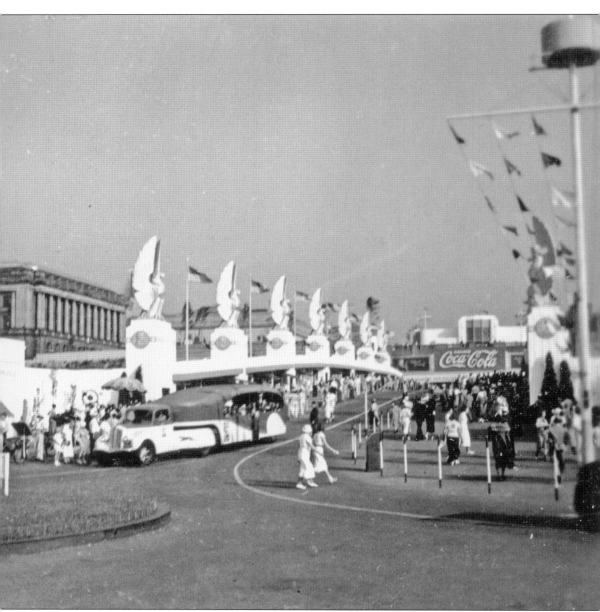

There is a lot to be seen in this early afternoon image that looks to the south from the Marine Plaza to the Avenue of the Presidents. Visitors can be seen boarding one of the Expo's many Greyhound transit buses in front of the Standard Drug Building at lower left, and the façades of the county courthouse and the Public Auditorium can be seen behind the sunlight-bathed pillars and gilded eagles on the left side of the avenue. At the southern end of the avenue, the Ohio Building towers above the overlook of the Court of the Great Lakes, over the large "Drink Coca-Cola" sign. There are quite a few people milling about, checking out food and souvenirs. At far right, a mast topped with a crow's nest and draped with colorful nautical flags announces to visitors that they have reached the Marine Plaza. (Author's collection.)

The view above looks south toward Cleveland's iconic Terminal Tower. The tower was built as an office building atop the city's new underground rail station, which supplanted the lakeside station that was proposed in Burnham's Group Plan. Below, people can be seen walking along the Avenue of the Presidents' causeway, crowding the shops and food stands. The Marine Theatre, which would have been behind the photographer, featured swimming and diving demonstrations throughout the day. Marine Theatre performers complained about the lake's cold temperature, the dirtiness of the water, and the choppiness of the lake on windy days. The Marine Theatre was not very popular, and was replaced by Billy Rose's wildly popular Aquacade during the 1937 season. (Above, author's collection; below, CMP.)

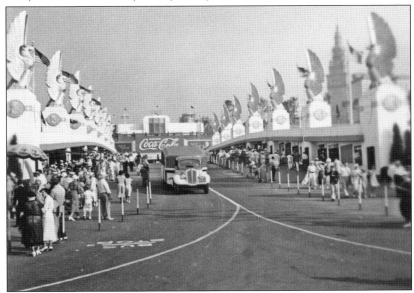

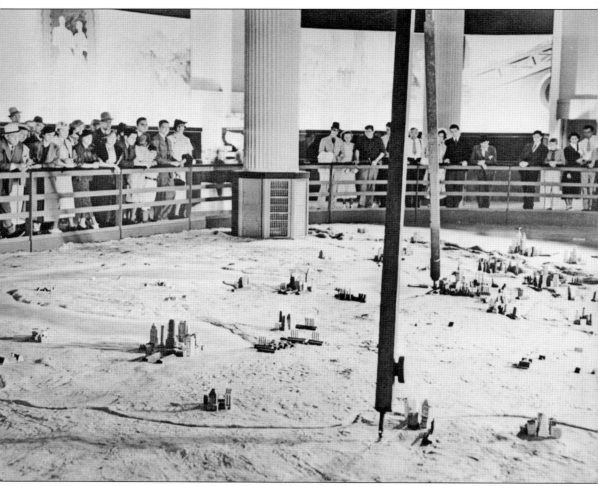

This three-dimensional topographical map of the Great Lakes, which was located in the Century of Progress attraction on the Marine Plaza, presented an opportunity for visitors to gain a perspective of the extent of the Great Lakes region and of the placement of its major cities and geographical features. In the mid-1930s, very few people had had the opportunity to fly in an airplane, so the bird's-eye perspective presented by this feature would have been a unique one. This feature was constructed and installed by workers employed through the federal government's Works Project Administration. (CMP.)

Three

GRAND VIEWS

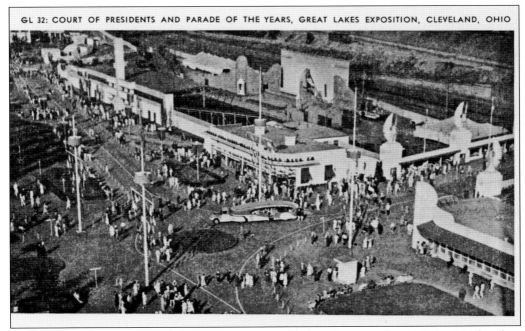

GL 32: COURT OF PRESIDENTS AND PARADE OF THE YEARS, GREAT LAKES EXPOSITION, CLEVELAND, OHIO

The last of the Expo's sections that visitors encountered before they arrived at the Lake Erie shoreline was the Marine Plaza, which was a broad, landscaped nautically themed boulevard. The impressive Automotive Building, which was on this boulevard, housed exhibits of the history, innovations, and the most advanced contributions of the automotive industries. Other attractions on the plaza included the Hall of Progress, the Enamel Building, and Municipal Stadium. (CMP.)

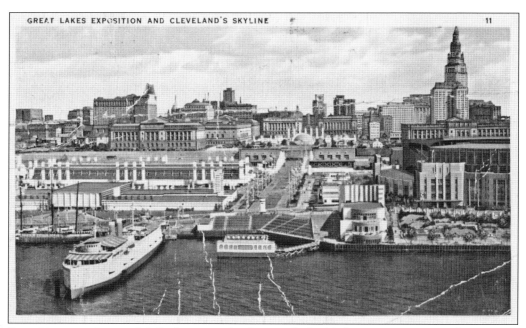

Exposition organizers took full advantage of its location by highlighting marine-oriented attractions along the Lake Erie shoreline. Parades of beautiful yachts, speedboat rides, and thrilling hydroplane boat races might have seemed out-of-place to most people during the financially stressed Depression years, but for those who attended the Exposition, it was a chance to immerse themselves in a fantasy world for the day and leave the troubles of the real world behind. This was the Great Lakes Exposition, and except for the Old World architecture of the Streets of the World section, the predominant architectural theme was nautical, with sweeping curves and multi layered, stacked forms that resembled the prows of ships, as can be seen in the view of the Horticulture Building in the foreground of the image below. A number of visitors from the upper Great Lakes region traveled to the Exposition by one of the many large steam-powered side-wheel cruise ships that operated on regular schedules in prewar times. One of these can be seen docked behind the *Moses Cleaveland*, which housed a floating nightclub. (Both, CMP.)

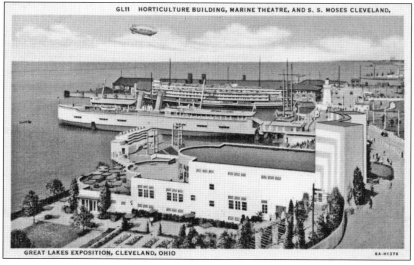

GL11 HORTICULTURE BUILDING, MARINE THEATRE, AND S. S. MOSES CLEVELAND,

GREAT LAKES EXPOSITION, CLEVELAND, OHIO 6A-H1378

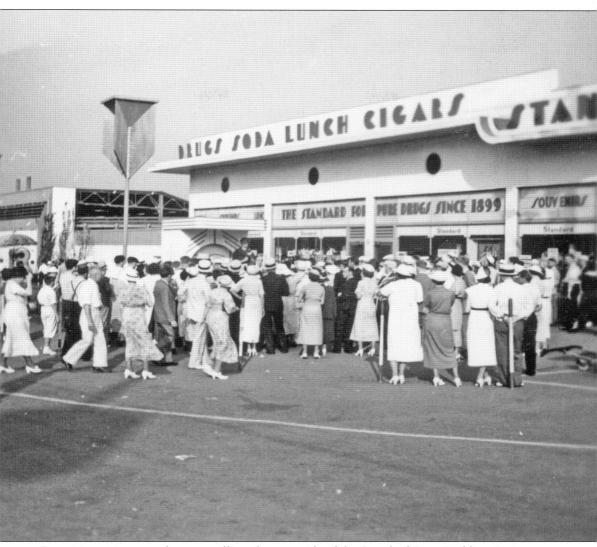

Exposition visitors can be seen milling about outside of the Standard Drug Building. Visitors to this popular intersection would get their first views of the very modernly designed Automotive Building. The sweeping architecture of the Standard Drug Building occupied the northeast corner of the intersection of the Boulevard of the Presidents and the Marine Plaza. This intersection was one of the most popular spots on the Expo grounds. The Standard Drug Building included a full drugstore, a 120-foot soda fountain that served sandwiches and drinks, and a full-service restaurant. As indicated by the sign on the building, Expo visitors could also purchase a full line of cigarettes, cigars, candy, and souvenirs. The Standard Drug Building was at the head of the Exposition's lower level. To the east of the Standard Drug Building was an immense amphitheater where the epic spectacle "Parade of the Years" was staged, and just beyond it to the north was the whimsically and monumentally designed Automotive Building. (Author's collection.)

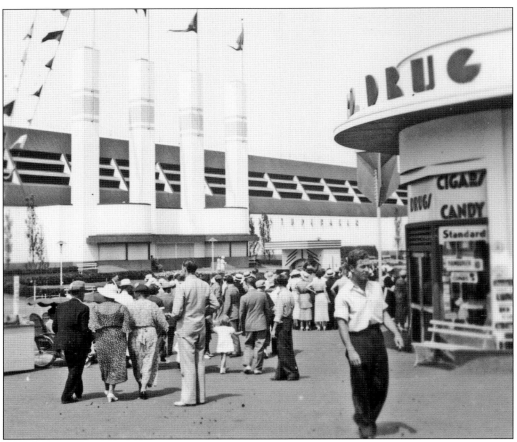

The image above shows the northern corner of the Standard Drug Building and part of the Automotive Building. Like many of the Great Lakes Exposition's buildings, these buildings showed the influences of the Art Deco movement's streamlined design motif. This style was fitting for the Exposition, and many of its buildings took on nautical themes, featuring sweeping corners and incorporating features such as the towers of the Automotive Building that resemble a ship's funnels and the building's louvered roof, which gives the impression of an ocean liner. At left, three generations of women can be seen resting on a bench underneath a spray of flags at the northern end of the Avenue of the Presidents, where it intersected with the Marine Plaza. (Both, author's collection.)

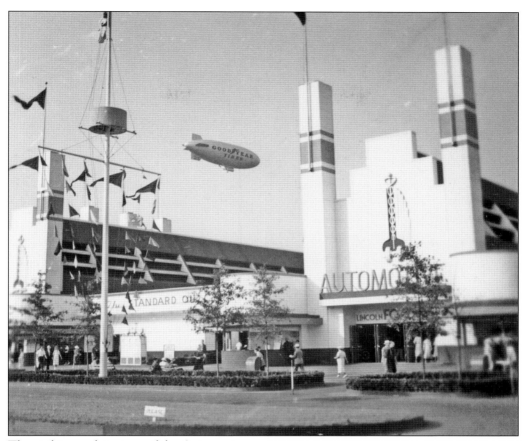

The striking architecture of the Automotive Building can be seen in this photograph of its entrance. It is amazing that the Expo's elaborate buildings were initially intended to last only for 100 days. The Automotive Building's thirty-two 70-foot-high pylons were brightly lit at night. Combined with its colorful exterior and flags, it created a festival effect. The building's architecture was described at the time as being "ultra-modern American," and its style was described as "simple, straight-forward, colorful and severe." Like many of the Expo's buildings, the Automotive Building was windowless, allowing uniform lighting of displays throughout the day. Inside the 540-foot-by-228-foot building were displays of automobiles, stagecoaches, and visions of transportation in the future. The building consisted of two side-by-side structures with a landscaped exhibition court in between. (Both, author's collection.)

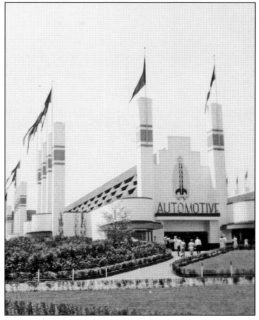

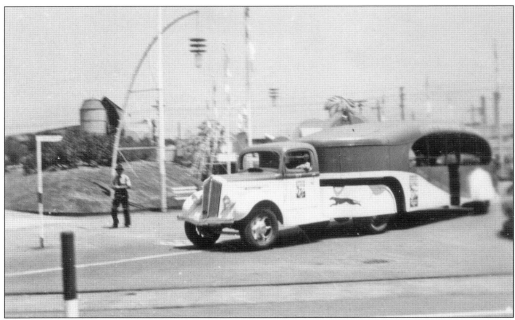

These photographs show two of the Exposition's many mini-buses that were operated by the Greyhound Corporation. The articulating passenger buses were pulled by White Motors cabs. These buses were specially built for the Exposition, and for a 10¢ fare, they would take visitors to any part of the grounds. The buses left from terminals at each of the Expo's four entrances on a set schedule. Visitors could take in all of the Expo's many features by taking a bus tour that included a driver who told them about attractions as the bus drove around the grounds. A cast metal model of the buses became one of the Exposition's favorite souvenirs, and they are still in demand today. (Both, author's collection.)

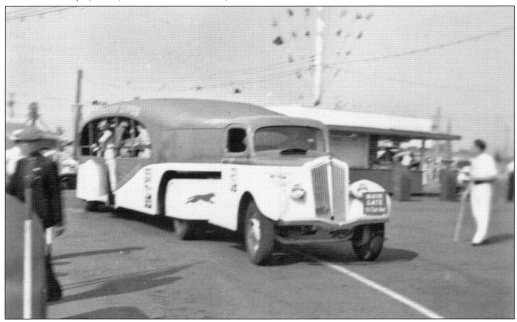

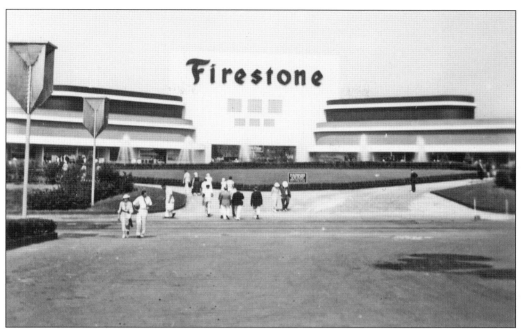

The Firestone Corporation, which had its world headquarters in nearby Akron, was one of the Exposition's main sponsors. As such, the Firestone Building occupied one of the largest spaces on the grounds. The inside of the Firestone Building included numerous exhibits of the rubber industry, including a large display that showed how raw materials were converted into finished rubber goods. World War II erupted only a few years after the Exposition's two-year run, and the Firestone and the Goodyear Tire and Rubber Corporation's rubber production operations greatly aided the United States' ability to transport materials during the war. (Both, author's collection.)

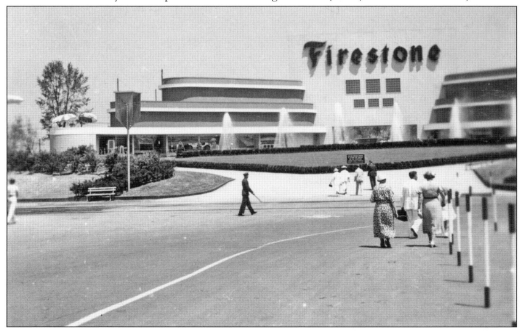

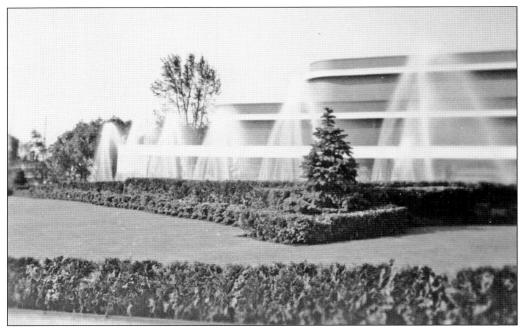

The Exposition's Singing Fountains were adjacent to the Firestone Building. This set of six fountains sprayed water into the air accompanied by music and was colorfully lit by a sophisticated system of lights that changed their color according to the pitch of the music. The fountains and their controls were very advanced for their time. Reddish lights were activated when low-pitched musical tones sounded, and as the music hit higher pitches, the colors ranged through the rainbow. At the time, it was the only feature of its kind in the world. The combination of the dancing sprays of water, changing colored lights, and beautiful concert music captivated visitors, and the benches and other seating areas became hot properties. (Both, author's collection.)

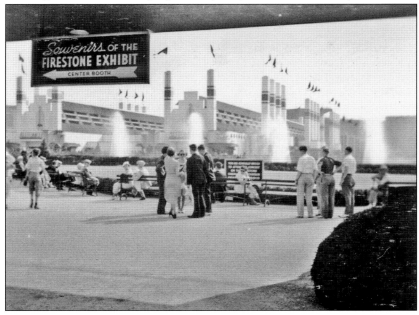

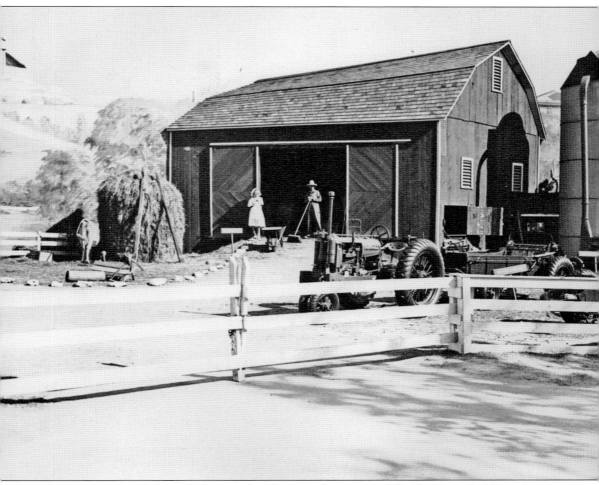

When visitors passed through the grand archway at the center of the Firestone Building, they came upon a very surprising and unusual sight. Instead of an expected industrial display, they came face-to-face with a typical American farm, complete with waving fields of grain, a barn, a farmhouse, a farm implement shed, live cows and chickens, and other farm equipment. Most of the farm materials were transported to the Exposition from the Ohio farm of Harvey S. Firestone, who was the Firestone Corporation's founder. The farm display was added to the Firestone exhibit to highlight the humble beginnings of the Firestone family and connect the company and the highly industrialized rubber industry with the Great Lakes region's agricultural economy and the "common man." (CMP.)

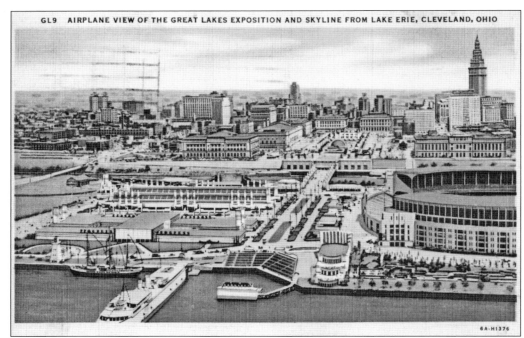

The Showboat nightclub and restaurant was an Exposition feature that occupied an entire deck of the great lakes transport ship *Moses Cleaveland*, which was moored just east of the Expo's Horticulture Building, as can be seen in both of these postcards. The ship is pictured above before it was transformed into the Showboat nightclub, and is pictured afterward in the image below. Showboat was accessed by a gangplank from the shore or by a hanging ladder for those who arrived by boat or yacht. The 350-foot ship had been entirely rebuilt, luxuriously furnished, and decorated to make it into a palatial nightclub. Two nationally famous dance orchestras played during nightclub dinner shows, and strolling players and singers provided further entertainment on-deck. The nightclub included a nautical bar, with attendants in seafaring attire, and full meals were served throughout the day. Admission to the Showboat was 25¢ during the day and 50¢ in the evening. (Both, CMP.)

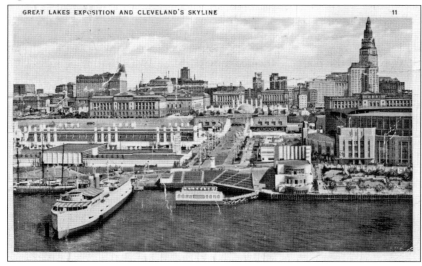

GREAT LAKES EXPOSITION AND CLEVELAND'S SKYLINE 11

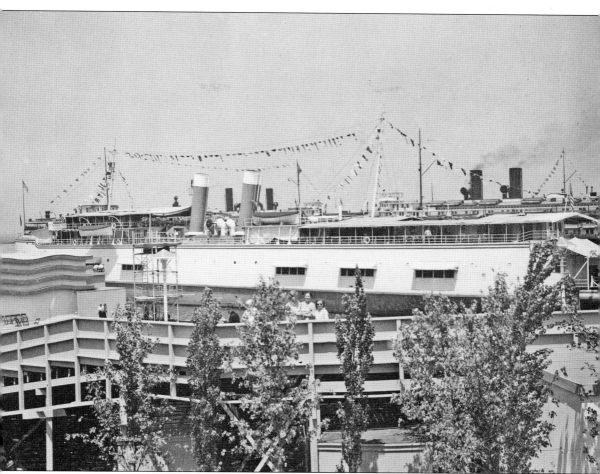

The *Moses Cleaveland*, named after the founder of the city (the city's name was shortened from the original spelling), was the home of Exposition officials and a club for sponsors. Notably, Pres. Franklin D. Roosevelt lunched with local politicians and businessmen on it, and he and Eleanor Roosevelt were overnight guests aboard the *Cleaveland* when they visited the Exposition. The nearby Marine Theatre presented a varied program of expert synchronized swimming and diving programs that presaged the poolside-themed movies of the 1940s that made Esther Williams a star. Taken together, the ship's high-class nightclub entertainment, the elegance of the nearby Horticulture Building, and the view of brightly-colored yachts on the lake must have made Expo-goers feel like they were in New York City or in the Hamptons instead of in Cleveland on the Lake Erie shoreline. In this image, people can be seen walking in the eastern end of the Horticultural Gardens just west of the Horticulture Building. (CMP.)

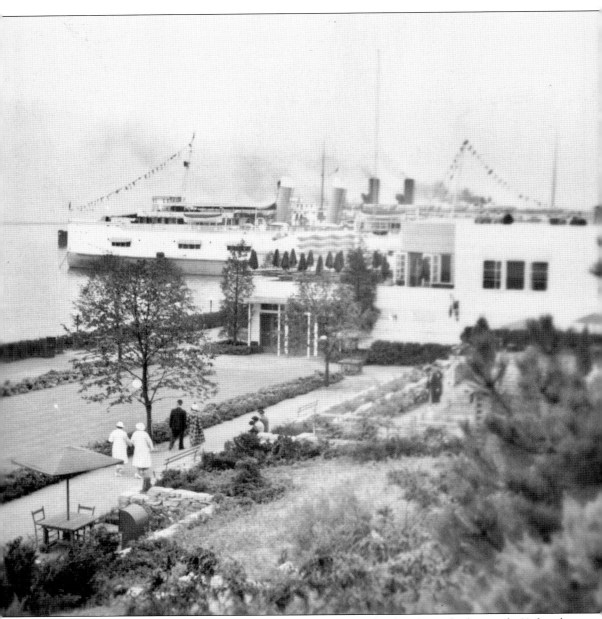

Along the lakefront at the north end of the Expo grounds, the elegantly-designed, 60-foot by 190-foot Horticulture Building and the 1,000-foot-long Horticultural Gardens offered visitors one of the largest horticultural displays of its time. The Horticulture Building featured ever-changing flower and horticultural shows that were presented by both national distributors and local flower and garden clubs. The gardens were divided into a number of sections, one of which was a series of 10 gardens symbolic of Cleveland's gardening history. These gardens ranged from simple garden plots with a combination of flowers and vegetables of the early settlers, to elaborate gardens of the 1890s, to World War I Victory Gardens, to modern gardens that featured the newest varieties of hybridized flowers, shrubs, and trees from around the world. (Author's collection.)

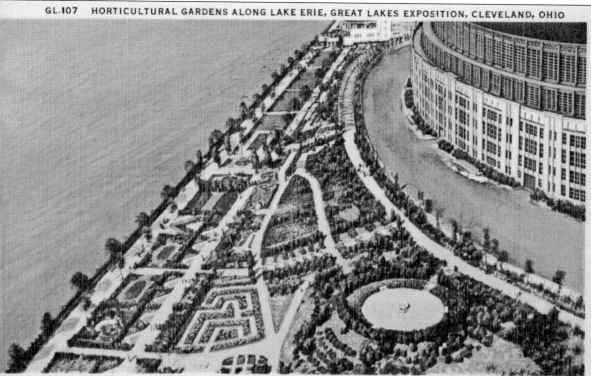

7A-H1215

The Donald Gray Gardens, known at the time of the Great Lakes Exposition as the Horticultural Gardens, were designed for the Exposition by Cleveland-based landscape architect and designer Donald A. Gray. Built to be a permanent addition to Cleveland's lakefront, the gardens and the Horticulture Building were two of the Expo's longest-surviving attractions. While nearly all of the Exposition buildings were torn down immediately after the end of the Expo's two-year run, the Horticulture Building and the gardens were left in place as a gift to the city by the Exposition's organizers. The Horticulture Building was faced with newly developed plywood sheathing and burned down only four years after the Exposition closed. The remnants of the Donald Gray Gardens lasted until 1999, when they were removed to make way for the Cleveland Browns' new FirstEnergy Stadium. Statuary and fountains from the gardens were removed over the years, and some were relocated to other Cleveland-area gardens. (CMP.)

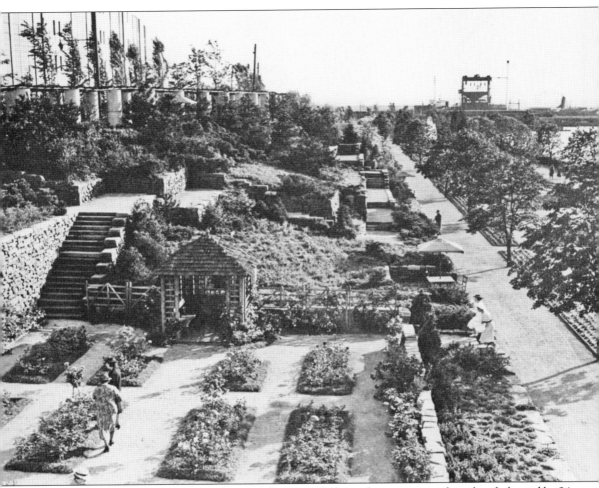

The Cultural Gardens section featured flowers and plants that were contributed and planted by 24 of Cleveland's nationality groups. The floral displays in these gardens were changed throughout the summer to keep up with each plant's flowering season. The gardens included a 500-foot hillside with rock gardens, waterfalls, and rare plants; a large fountain; and a reflecting pool. One section featured an evergreen garden, and another featured rare varieties of shrubs and the newest types of annuals. The Cultural Gardens included garden plots that evoked images of Ireland, Syria, Britain, Hungary, Germany, Lithuania, Greece, Italy, Slovakia, Slovenia, Bohemia, Yugoslavia, Russia, the Ukraine, Romania, and Scandinavia. (CMP.)

The Horticultural Gardens included ethnic, educational, and historical gardens. They also included a series of formal spaces with fountains, sculptures, and pools. These gardens were built to be a permanent gift to the city of Cleveland; while they ended up being the Exposition's longest-lived feature, they were gradually phased-out over the 50 years after the Exposition closed. Many of the garden's features were moved from the Donald Gray Gardens to other locations around the Cleveland area over the years. One of the garden's last remaining features, before it was dismantled to make way for the construction of FirstEnergy Stadium, was a hillside waterfall. (Above, CMP; below, author's collection.)

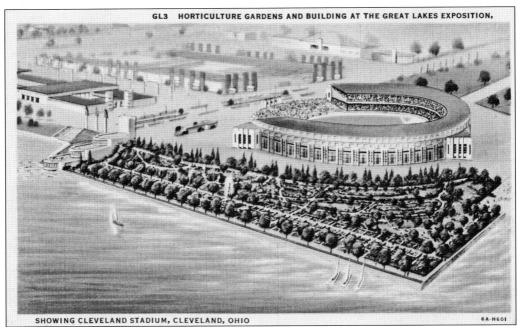

SHOWING CLEVELAND STADIUM, CLEVELAND, OHIO 6A-H601

To the right above is Cleveland's Memorial Stadium, and between the stadium and Lake Erie are the 1,000-foot-long hillside gardens of the Exposition's Horticultural Gardens. Visible at far left, the Exposition's Horticulture Building resembled the tiered prow of an ocean liner. Memorial Stadium seated 80,000 people, and during the Exposition, it was host to daily athletic contests and displays. During the summers of 1936 and 1937, the Cleveland Indians temporarily left their home at League Park, and in later years, the stadium became the home to both the Indians and the Cleveland Browns. The stadium also hosted track and field meets, bicycle races, and soccer matches, along with nationality group athletic events, football games, and ski jumping competitions. In the Exposition's first summer, the Marine Theatre's floating stage offered daytime swimming and diving shows during the day and fashion and style shows in the evening. Even though sheltered from Lake Erie's ferocity by the floating stage and the break wall that can be seen to the left below, movie footage from the time shows that swimmers had difficulty carrying out their synchronized swimming routine in the lake's choppy waters. (Both, CMP.)

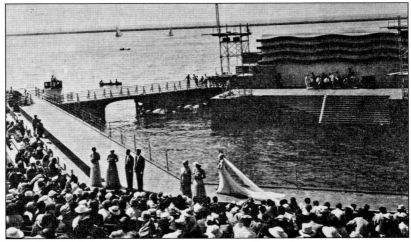

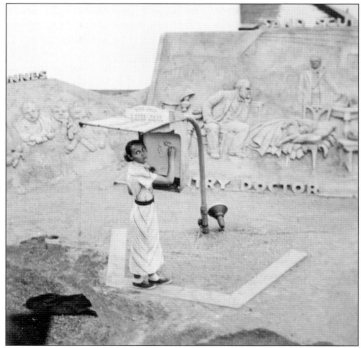

Above, a crowd watches the Exposition's seaside sketchers as they stand at their shaded easels in a sand pit that housed one of Claudie Bell's sand sculptures. At right, a sketch artist works in front of another two of Bell's sculptures entitled "The Country Doctor" and "The Dionnes." The Dionne quintuplets were a sensation of the 1930s, and after a plan for them to open the Expo's Radioland remotely from Ontario could not be arranged, Bell created this sand sculpture in just three days at the request of Exposition organizers. (Both, author's collection.)

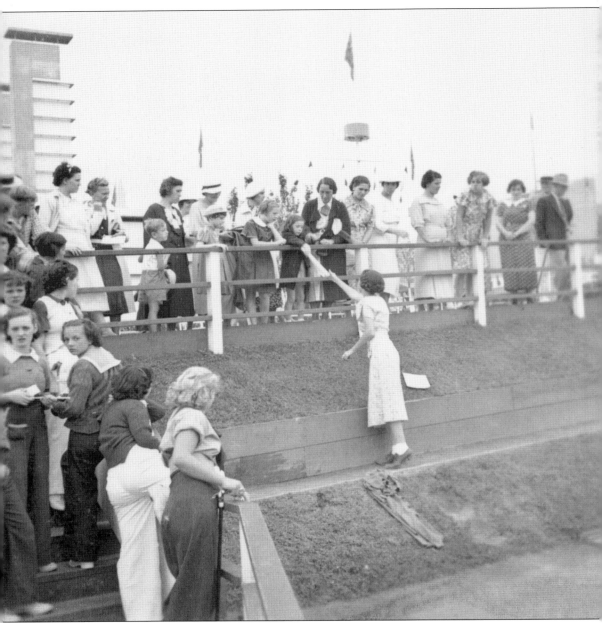

One of the Exposition's seaside sketch artists can be seen reaching up to hand a rolled-up finished sketch to a young girl. It is unknown why this arrangement was used, because it looks like having the sketchers so far removed from their subjects would not have facilitated the production of their sketches. The futuristic-looking pillars of the Progress Building can be seen in the background to the left, and two of the Marine Plaza's masts and a portion of the Municipal Stadium can be seen in the background to the right. (Author's collection.)

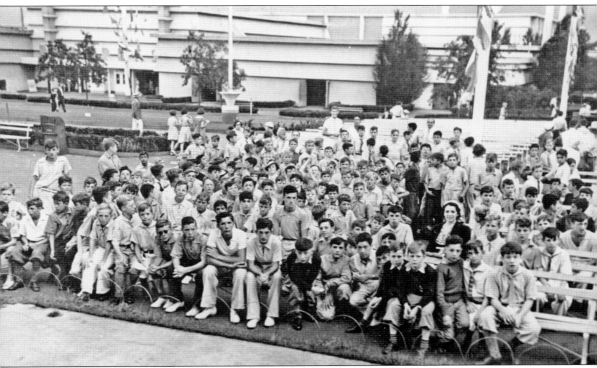

This image shows a group of boys from the Parmadale Children's Home seated along the Lake Erie shoreline next to one of the sand sculpture pits during their day at the Exposition. It is possible that the group is watching Atlantic City's Claudie Bell work on a sand sculpture or watching the sketch artists. The Exposition had special days throughout the summer for different groups and offered special admission rates for them. The Parmadale Children's Home was constructed in the 1920s by the Cleveland Catholic Diocese as a residential home for orphaned boys. It eventually was expanded over the years to house both sexes. The institution closed in 2014. (CMP.)

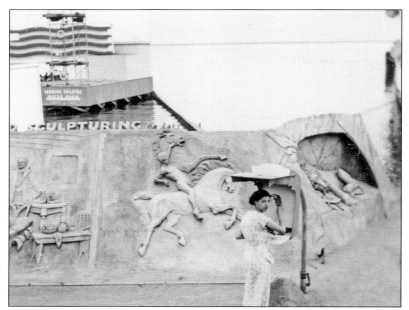

These images provide a view to the right of the image on page 63. The sand sculptures include "The Country Doctor," what appears to be an unfinished sculpture of two horses and a rider, and Bell's sand sculpture reproduction of Bertel Thorvaldson's famous 1820 cliffside sculpture, the Lion of Lucerne. Thorvaldson's work commemorated the bravery of a group of Swiss guards who were killed while defending a palace during the French Revolution. A comparison of Thorvaldson's original work and the exactness of Bell's sand reproduction highlights Bell's skill at capturing details in a challenging medium. In the 1880s, Mark Twain praised Thorvaldson's sculpture of a mortally wounded lion as "the most mournful and moving piece of stone in the world." The wording on the top edge of the sand wall reads, "Sand Sculpturing by Bell." The Marine Theatre's floating stage can be seen in the background, announcing water shows at 4:00 p.m. and 7:30 p.m. (Both, author's collection.)

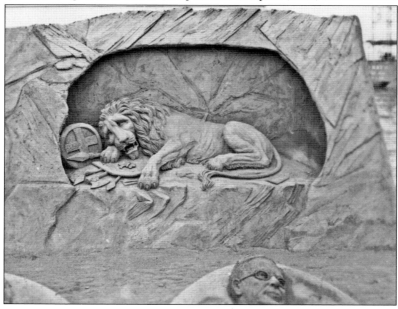

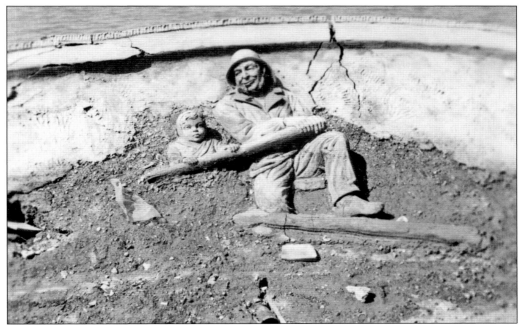

These two images capture one of Claudie Bell's works in progress. Outside of these photographs that appear in this book for the first time, there are no other known images of Bell's work from the Great Lakes Exposition. The image above was taken earlier in the day and shows the partially finished sand sculpture of a man and a child in a rowboat. The title of this work was "Just a Few Grains of Sand." The image below was taken later in the day and shows the completed sculpture. It is not known how many sand sculptures Claudie Bell produced during the Exposition or how long his sculptures lasted after they were completed. It is interesting to note the drainage pipe at the bottom left of the boat in the image below. (Both, author's collection.)

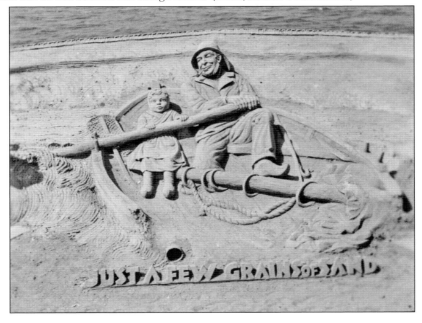

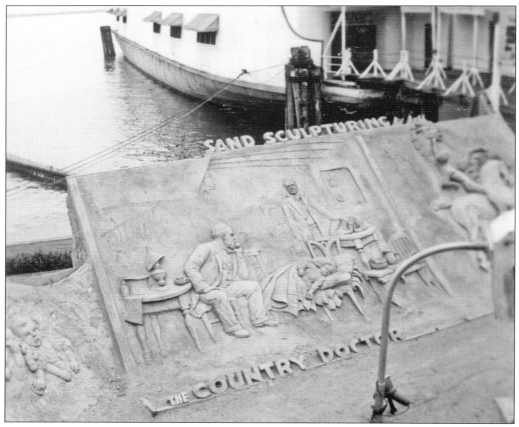

The image above shows another view of Bell's sand sculpture "The Country Doctor," with a view of the *Samuel B. Mather* lake transport ship in the background. The *Mather* was transformed into the Showboat entertainment facility during the 1936 Exposition year. In the second year, the ship's onboard entertainment offerings were changed from a nightclub atmosphere to a Germanic restaurant. At left is a man resting on a bench inside the Cleveland Museum of Art's 20th anniversary exhibit of art that was displayed in a semicircular building that made good use of natural light. The Cleveland Art Museum gathered famous works of art, including paintings and sculpture from around the world, for special displays both at the museum at the head of the Wade Park Oval in the University Circle area and at the Exposition. (Both, author's collection.)

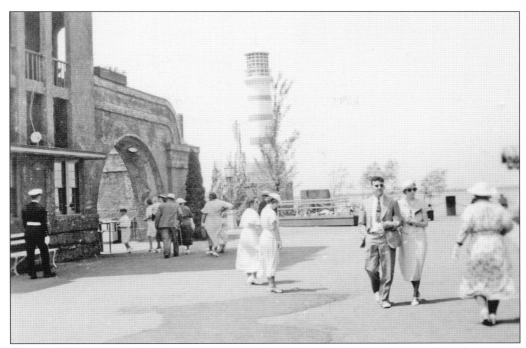

Cleveland's Municipal Stadium, seen above to the left, was only a few years old at the time of the Exposition, but in this image, it already looks ancient. Some of the people in the picture are entering the stadium gates, possibly to see an early afternoon baseball game. An additional feature is the Lighthouse, which Expo visitors saw when looking north down the length of the Avenue of the Presidents. Two of the Exposition's tallest structures, the Lighthouse and a tower at the corner of the Exposition's row of "seaside" restaurants, were both located along the Lake Erie shoreline and are featured below. (Both, author's collection.)

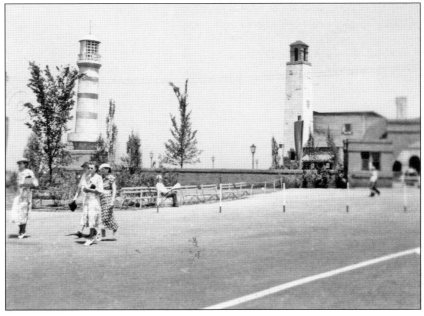

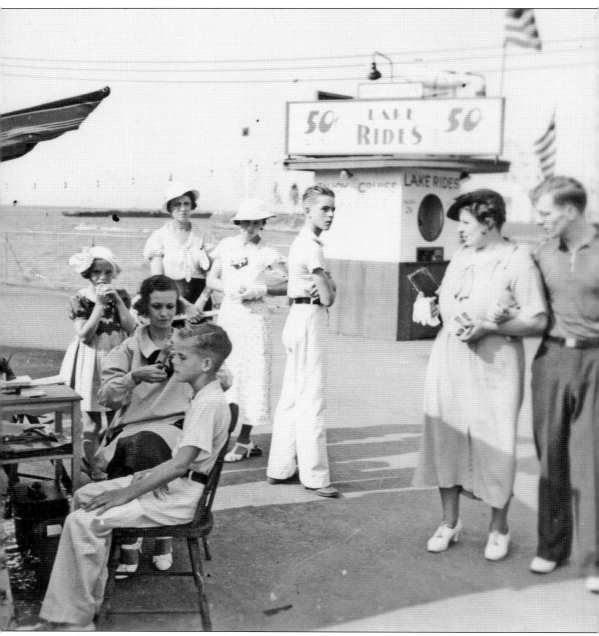

A couple, possibly the boy in the chair's parents, and other people watch as a profile artist uses scissors to cut his profile into a piece of paper that will be framed for him to take home. Also visible is a young girl in a native costume who is perhaps waiting her turn, and a ticket booth advertising lake rides for 50¢ for adults and 25¢ for children. The sign reads, "Enjoy a Cruise on Lake Erie." Cleveland's Exposition was similar to Chicago's 1930s-era Exposition in that they were both located along a lake, although it was felt by many at the time that Cleveland's Expo took better advantage of its lakeshore resources than Chicago did. (Author's collection.)

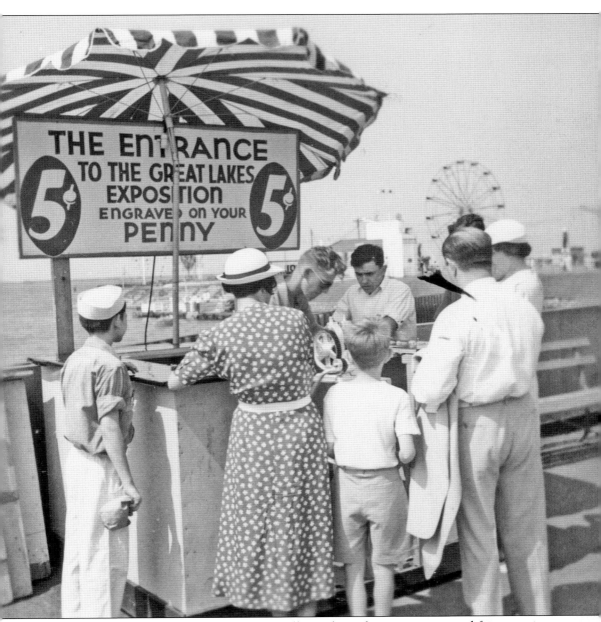

This photograph shows a feature that is still popular today at museums and fairs: carving or stamping a souvenir image onto a common penny. Today, a penny and two quarters are inserted into slots in a machine that automatically presses an image onto the flattened penny. In this 1930s version, it appears that the man in the darkened goggles is using a manual wheel-driven machine to flatten a penny and then hand-stamping an image of "The Entrance to the Great Lakes Exposition" onto the penny's surface. All of this hand labor was performed for only 5¢. The Midway's Ferris wheel can be seen in the distance. There were many features in the Exposition's Midway, Amusement area, and Streets of the World that children could enjoy, but because the Expo also featured so much female nudity and was relatively expensive, few children are seen in this book's pictures. (Author's collection.)

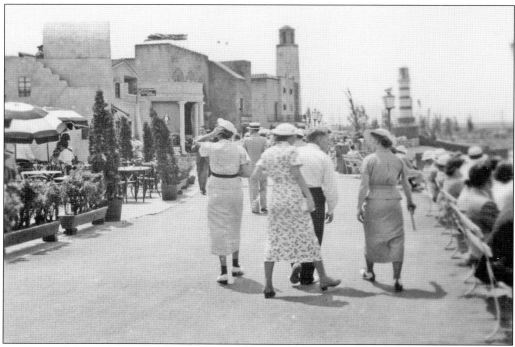

Exposition organizers chose to place a row of restaurants from countries that were located on the ocean along the Lake Erie shoreline. Restaurants shown above are, from left to right, the French Casino, Frank Monaco's restaurant, the Grand Restaurant, an Italian deli, and the Mexican House restaurant. The Exposition's building designers did a great job of transporting Expo visitors to other parts of the world by capturing the textures and visual references of the world's architectural styles. The view below faces east, and Expo visitors can be seen strolling along the lakefront, sitting on lakefront benches, and enjoying Lake Erie's ever-present onshore breezes. Visible in the distance are the Lighthouse and the masts of the *City of New York*. (Both, author's collection.)

Judging by this final image of the Exposition's seaside avenue, dress at the Exposition was extremely formal by today's standards. Men wore jackets and ties, and women wore dresses, hats, and sometimes gloves. In this idyllic scene, couples can be seen strolling along the lakefront and sitting on benches facing the lake. The same restaurants that have been in previous photographs of this section of the Exposition can be seen here. Below, four women in white hats and white shoes and a mother and her son, who is dressed in shorts, are turning the corner in the early afternoon to enter the Exposition's Streets of the World section. (Both, author's collection.)

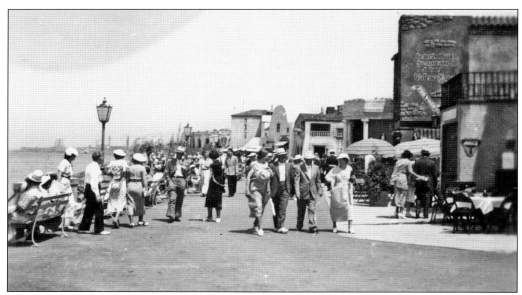

Exposition visitors could choose from hundreds of places to get food and snacks. Food from more than 30 ethnicities was available from handcarts, walk-up food stands, casual dining facilities, a central cafeteria, and fancier cantinas and restaurants like the ones that can be seen above lining the Lake Erie shoreline. The photographer shading the camera from the noonday sun likely caused the smudge in the upper-left portion of the image. Below, two small groups of people sit in the shade and enjoy a snack at the Downeyflake Doughnuts and Coffee Shoppe, while others browse the offerings of a gift shop in the African Village. At the Exposition, food offerings did not always match the theme of the section in which they were located. (Both, author's collection.)

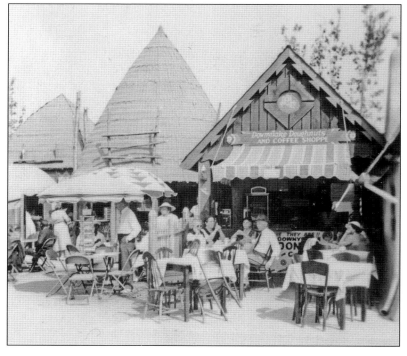

Four

GRAND TIMES

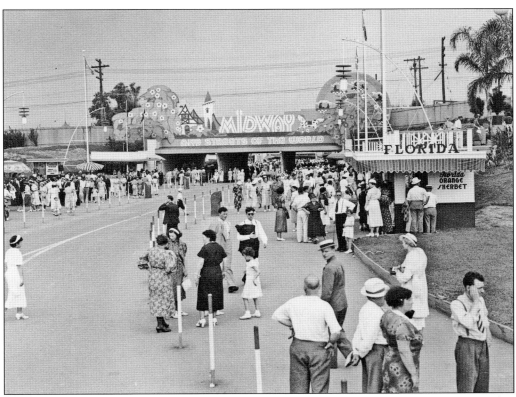

People gather at the entrance to the Midway and the Streets of the World at the Great Lakes Exposition. The Midway featured typical carnival-style entertainment, including rides and a variety show. The Streets of the World featured shopping, dining, and scenery representative of nearly 40 countries. (CMP.)

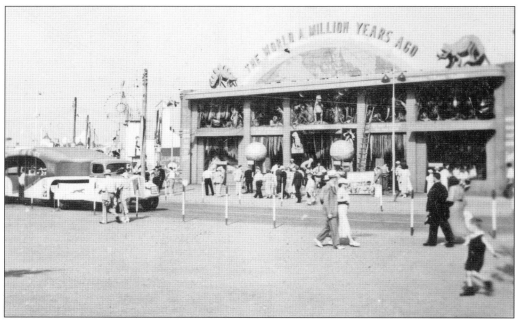

The World a Million Years Ago exhibit featured models of dinosaurs, mastodons, cave dwellers, and many other attractions. Dinosaurs would have been gone for nearly 70 million years, and some of the features of this exhibit would not appear until well after a million years ago, but in people's minds, the world a million years ago might have contained all of these things. Eager to match the success of other attractions that featured nudity, for a short time, this attraction featured two dancing cavewomen named Oola and Boola. This image looks to the west, where two circular ship's wheel lighting fixtures from the Midway section and one of the masts from the Marine Plaza can be seen. Also pictured is one of the Exposition's Greyhound buses that transported visitors around the Expo grounds. (Author's collection.)

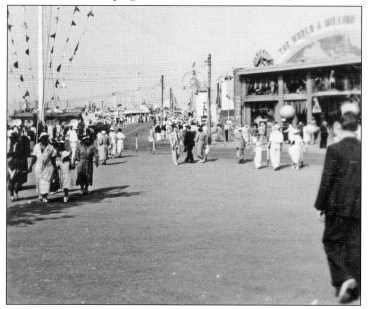

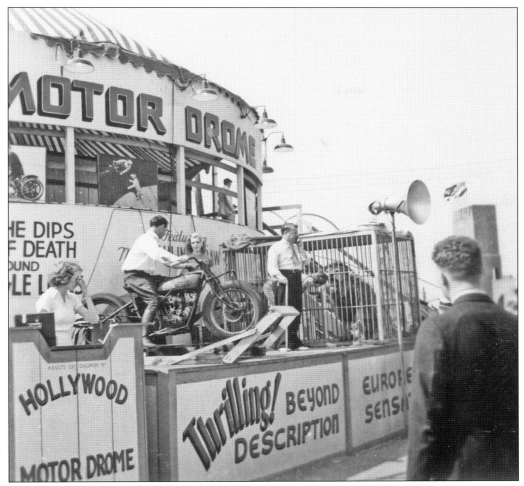

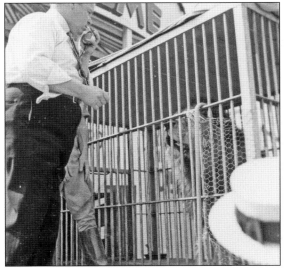

The Amusement Zone featured an outstanding variety of acts. Here, a barker (with his iconic cane) draws a crowd to the Hollywood Motor Drome, a "European Sensation, where patrons could watch men on motorcycles ride up onto the walls of a circular building, risking the "Dips of Death Around Jungle Lions." Yes, visitors could stand on an elevated platform and watch an untethered lion leap up toward a person riding around walls on a motorcycle. A view of a lion doing just that can be seen in the picture posted behind the man on the motorcycle on the marquee. A caged lion can be seen above to the right and in the image at right. It is safe to say that this kind of entertainment would not be offered today. (Both, author's collection.)

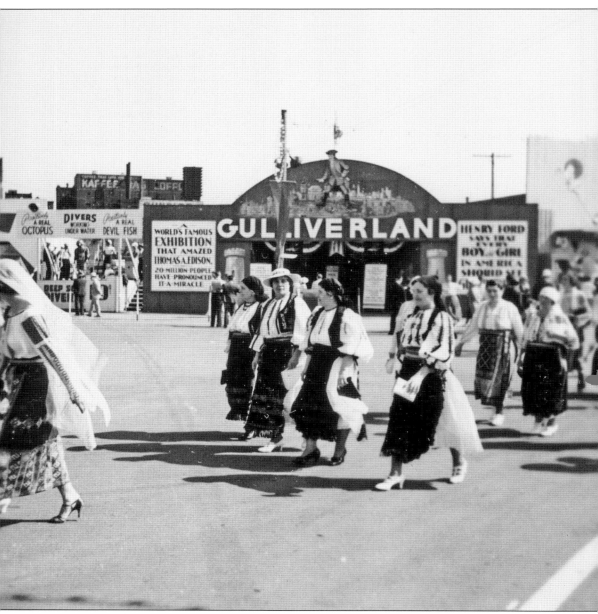

A group of women in ethnic clothing can be seen walking past Gulliverland on the Midway. A sign on the building says, "Henry Ford Says That Every Boy and Girl in America Should See Gulliverland." Another reads, "A World's Famous Exhibition That Amazed Thomas A. Edison. 20-Million People Have Pronounced It A Miracle." A feature next to Gulliverland advertises that for 10¢, visitors could see a deep-sea diver get into a tank with a real octopus and a real devilfish. Both the octopus and the devilfish were dead, but they were real. (Author's collection.)

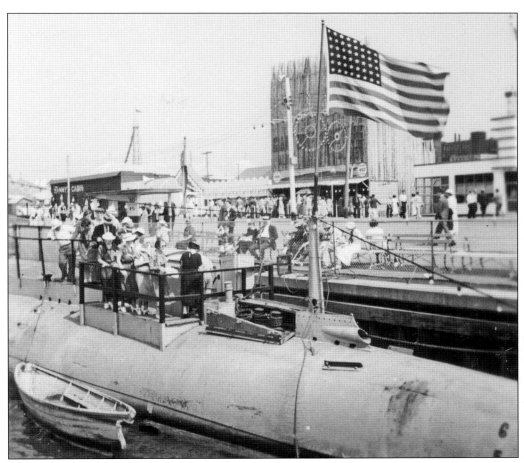

The Exposition featured tours of a retired US Navy World War I submarine, the S-49, which was towed to the Cleveland harbor from its mooring in Erie, Pennsylvania. Expo visitors could descend into the 240-foot submarine and view its mechanical controls, navigation systems, torpedo launching tubes, and emergency escape hatch. Seen in the background above is Mammy's Cabin, a restaurant that took the form of a Southern log cabin, where Southern favorites of chicken, waffle potatoes, and biscuits were prepared and served by "colored women." To add to the restaurant's old-time feel, patrons had to eat their meal with their fingers, as no cutlery was provided. Also visible is the bamboo-covered façade of Cliff Wilson's Snake Show, where patrons could view a pit of snakes and a 28-foot-long python named Elmer. (Both, author's collection.)

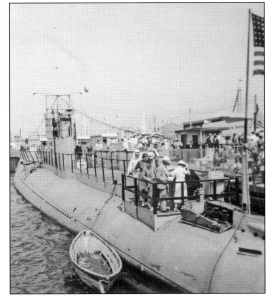

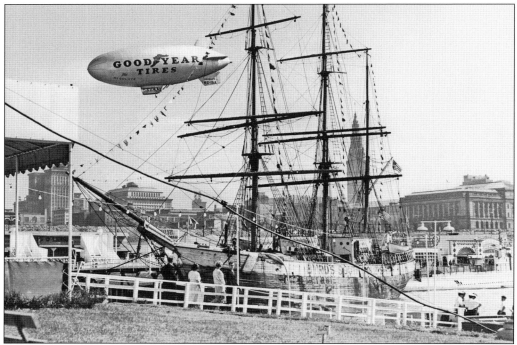

The ship that carried Admiral Byrd on his expedition to the Antarctic, the *City of New York*, was docked at the Exposition throughout its two-year run. Byrd's ship was originally constructed as the barkentine *Sampson* at Arendal, Norway, in 1885. After serving as Byrd's polar expedition ship, the *City of New York* became a floating museum, exhibiting relics, live penguins, and dog teams from Byrd's polar trips. After spending time at Chicago's Exposition and another two years docked at the Great Lakes Exposition in Cleveland, the *City of New York* became trapped in her Cleveland berth for an additional five years by a bridge that had been constructed since its arrival, and it remained there until it was called into service during World War II. Above, the Cleveland-based May Company department store's playland for little children can be seen just beyond Byrd's ship. The image below shows the *City of New York*'s gang plank side, with the Great Lakes excursion side-wheel steamship *Greater Buffalo* just beyond it. (Above, CMP; below, author's collection.)

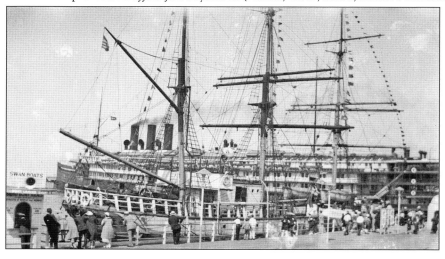

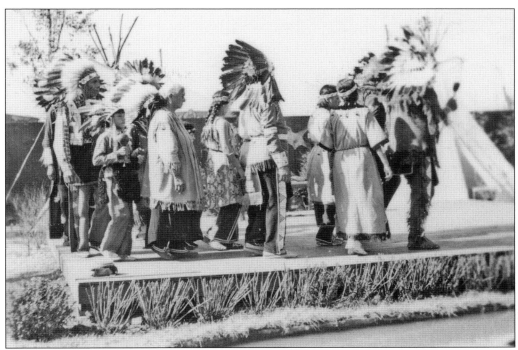

Chief A.H. Poodry and other full-blooded descendants of the fierce Iroquois tribes that once occupied the hunting grounds of northern Ohio were encamped at the Great Lakes Exposition throughout its run. These Native Americans demonstrated original dances in an atmosphere of tepees, crafts, and a pioneer stockade. Interestingly, the Exposition's lost-child center was located at the Native American encampment. Above, a group of Native Americans are seen wearing native costumes and headdresses, dancing in a circle on a stage, playing hand-held gourds. A tepee can be seen in the background on the right. Below, an unhappy-looking Chief Poodry of the Seneca Tribe poses outside the entrance to the Expo's Iroquois Indian Village, while an out-of-place barker in a pith helmet draws Exposition visitors to the attraction. (Both, author's collection.)

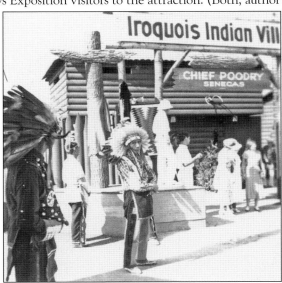

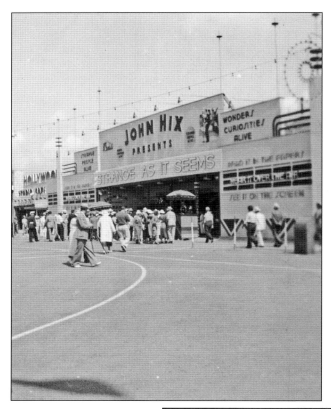

John Hix's *Strange As It Seems* attraction was seen at most of the 1930s Expositions across the country. Hix's venture, which featured strange people and creatures from around the world, was a competitor of *Ripley's Believe It Or Not!*, which replaced Hix's extravaganza for the 1937 version of the Expo. The attraction is seen to the left as it appeared on the Exposition's Midway. Below, Hix's barker gives a talk on the mysteries of the African continent, accompanied by an African native. A close look at the "native" reveals that he is dressed in a cheetah skin, bracelets, and a long white tie. He is also holding a Great Lakes Exposition brochure. The Expo's attractions were a reflection of their time; many features at the Expo would be considered in bad taste today. (Both, author's collection.)

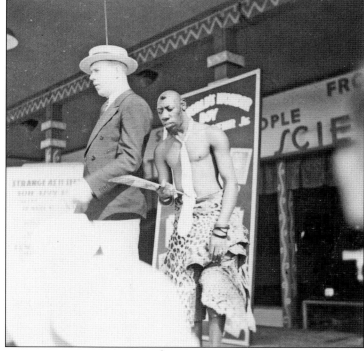

At the Monkey Land attraction, monkeys drove cars and performed other feats in a jungle-land atmosphere with huts and tropical scenery. At right, a barker in a safari campaign hat tells all within the sound of his amplified voice—including the young boy at lower left pressing in for a closer look—that for just 10¢, they could gain entry into the Monkey Circus, where they could watch trained monkeys perform and ride around a track in motorized cars. Below, everyone looks a little tired from a day's work, including the monkeys that sit patiently in their cars. (Both, author's collection.)

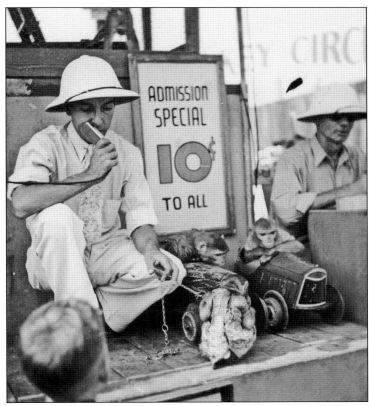

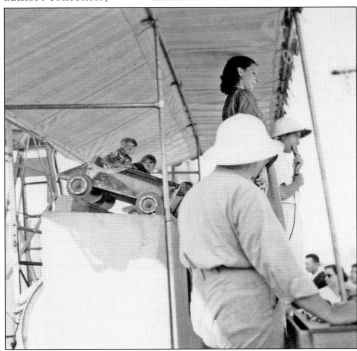

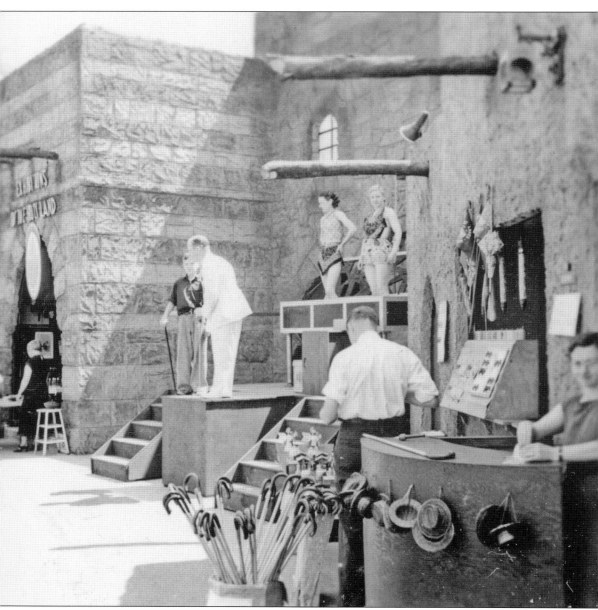

It is hard to tell what is going on at the Midway's Exhibitions of the Holy Land attraction. There are many souvenirs for sale, such as canes, hats, umbrellas, pennants, hair ties, figurines, prints, and more. Sex sold at the Expositions of the 1930s, and Cleveland's was no exception. Even an attraction named Exhibitions of the Holy Land had a couple of scantily clad young women on an elevated stand fronted by a barker in a white suit and cane trying to get patrons to buy something—an opportunity to come inside and learn more about the Holy Land or possibly get a closer look at the women. In this image, it is possible that the barker has called the uncomfortable-looking boy up onto the platform to tell him something about the Holy Land—or about the women. (Author's collection.)

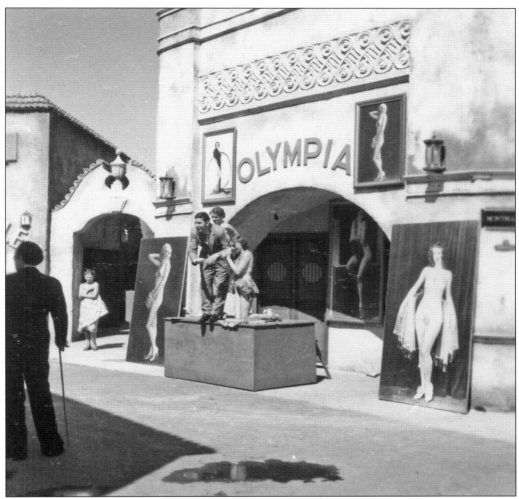

It is easy to see from this photograph that the Exposition probably was not the best place to bring children, unless a parent wanted to spend their day explaining why it was okay that there were so many life-size pictures of naked women in the Midway and the Streets of the World section. At the Olympia attraction, patrons paid money to go inside and see a nude woman—quite possibly the young woman standing off to the left—reclining on a piece of furniture, recreating the pose in Édouard Manet's painting of the same name. It has been reported that the model turned out to be only 14 years old, and the police removed her from the exhibit. It is hard to say what is going on out front of the Olympia attraction in this photograph. Is the man who is posing with the kneeling woman part of the show, or is he someone who was called up from the audience? Just to the left of the Olympia was the Keyhole attraction, which probably offered another chance to go inside and look at something patrons should not have been looking at. (Author's collection.)

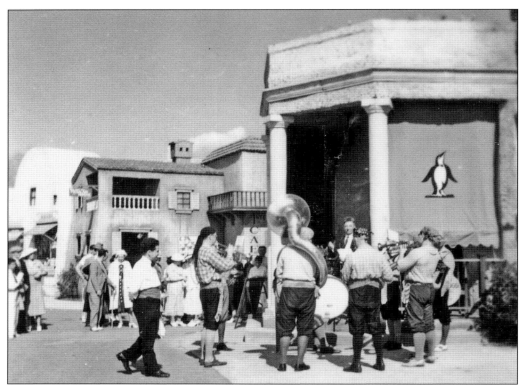

These days, it is hard to imagine this being a big deal, but in 1936, it was a big deal that the Great Lakes Exposition had a group of penguins on display. The building was located within the Streets of the World section, in the same area as the seaside restaurants. Granted, penguins were not being served at the Exposition, but they were from a seaside location. Above, from left to right, are a popcorn vendor (white building), the Mexican House restaurant, the International Café, and the penguin display. Also in this image, a small crowd has gathered to listen to one of the Expo's strolling bands. This oompah band is visible in several of the images in this book. The image below shows a close-up view of some of the penguins on display at the Exposition. (Above, author's collection; below, CMP.)

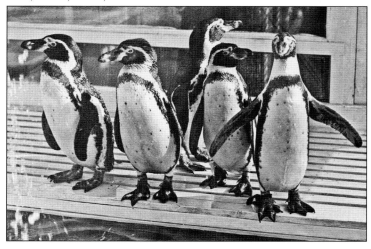

GL 38: HIGBEE TOWER AND FLORIDA EXHIBIT, GREAT LAKES EXPOSITION, CLEVELAND, OHIO

These two images of the Exposition's Florida exhibit capture some of the attraction's romance and Southern charm. The Florida exhibit tried to transport Exposition visitors to a different time and place, but unfortunately, in addition to the exhibit's fountains and palm trees, much of what they were transporting them to glorified the pre–Civil War south. More acceptable in the 1930s than it would be today, the exhibit included a Southern plantation house and fields with singing "slaves." The Higbee Building was an extension of Cleveland's Higbee Department store. Exposition visitors could purchase clothes and other department store goods here. The Florida exhibit did great things for Florida tourism. In the years following the Exposition, tourism from the Midwest increased greatly, and many people from the Great Lakes region left the cold and snow behind and moved to the south. (Both, CMP.)

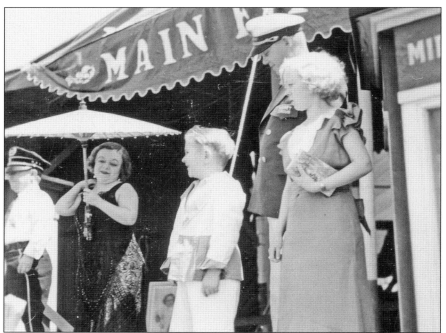

In the photograph above of the main entrance to Graham's World Famous Midget Circus, some of the feature's performers are seen on its outside stage. Graham's included attractions that were normally included in a circus side show, but was operated entirely by little people. The tent circus featured 24 little people, 24 horses, 14 dogs, 6 goats, and 3 elephants. Below, bandsmen are poised to play their instruments as some of the Midget Circus performers stand behind them. At the Exposition, watching and listening to outdoor stage acts and walking around the Midway and the avenues were covered by the general admission charge, but most of these special attractions required an extra fee to go inside. (Both, author's collection.)

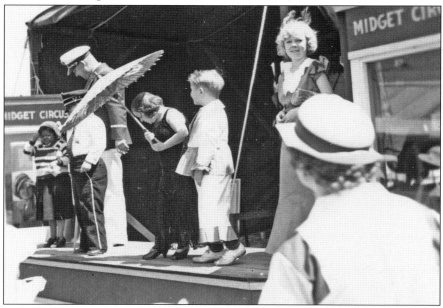

Old-world entertainment was a draw at the Exposition. The image to the right shows organ grinder Dominic Fantine's monkey doing tricks for a gathered crowd, and the image below shows the façade of the Old Globe Theatre attraction. Planned according to historic specifications, the reproduction of the 1600 London playhouse presented shortened versions of Shakespeare's plays that lasted less than an hour. On one side of the theater was an exact reproduction of the Old Curiosity Shoppe, made famous by Dickens, and on the other side of the building was a reproduction of an old English tavern. (Both, author's collection.)

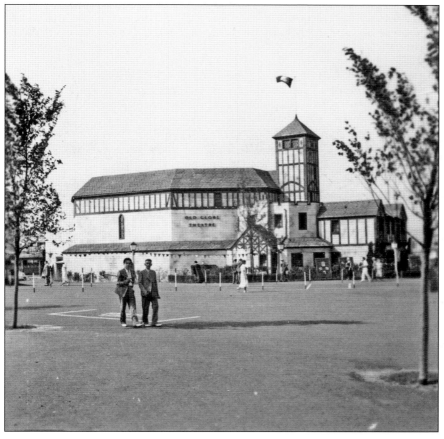

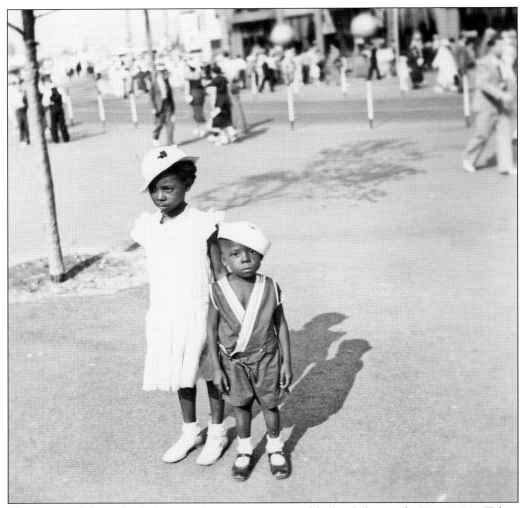

This is one of the author's favorite photographs captured by his father at the Exposition. Taken on the Midway, opposite the World a Million Years Ago attraction, this photograph of two African American children, possibly brother and sister, dressed in their best clothes illustrates what was most wrong about the Great Lakes Exposition's first summer. The Expo's organizers had a grand plan to deliver an extravaganza that could be enjoyed by young and old, and rich and poor; a grand event that would lift Cleveland up out of its Depression-era woes and celebrate the contributions of the Great Lakes' industrial and manufacturing region. Unfortunately, the organizers let the Expo develop into a spectacle that in many ways mirrored its times. There were reports at the time that some of the Expo's attractions barred African Americans, and its family-oriented educational exhibits were some of the least-popular attractions. Finally, the Exposition was awash with nudity and unsavory attractions, which made it unsuitable for children, including these two. (Author's collection.)

Five

A GRAND TOUR

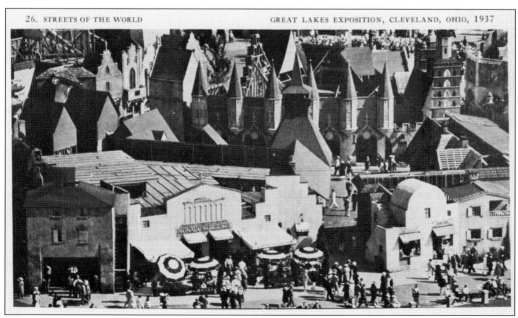

26. STREETS OF THE WORLD GREAT LAKES EXPOSITION, CLEVELAND, OHIO, 1937

The Exposition's Streets of the World section was divided into a collection of ethnic and nationality villages that offered a grand tour of the world on the shores of Lake Erie. The SOTW's ethnic villages highlighted the food, crafts, and music of nearly 40 countries. During the Exposition, most of the world was at peace and celebrated each other's cultures, but in only three years, the world would be at war. (CMP.)

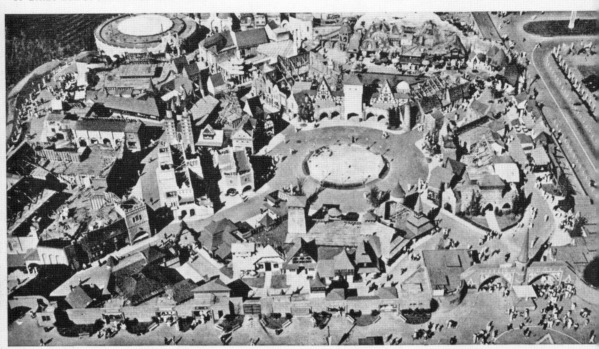

This bird's-eye view of the Exposition's Streets of the World section provides a good overview of its organization and layout. As a reference to later images in this chapter, north is to the left in this image, and east is to the top. Exposition visitors entered the SOTW through the towered gate at bottom right. The International Circle and the International Stage are at the center. The German Village is directly to the east of the International Circle, and the Alpine Village, with its partially-visible Matterhorn feature, is directly behind it. The main street of the French Village, which led to the French Casino (the large circular building at upper left), is to the left of German Village, and the façade of the Syrian Temple of Dance can be seen just to the right of the Casino. A closer look at the left side of the image reveals that some of the structures were false fronts, like those used on movie sets. (CMP.)

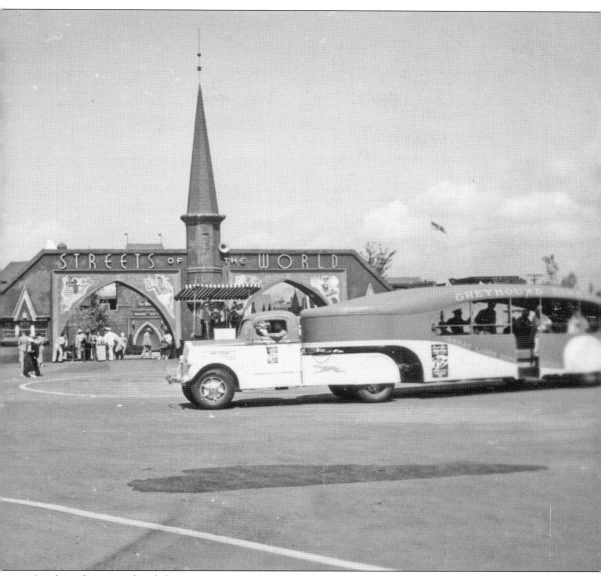

In this photograph of the entrance to the SOTW section, the silhouette of an Exposition policeman is seen assisting people getting on and off one of the Expo's Greyhound transport buses, while a German oompah band plays on the barker's platform between the two arched entryways. The Exposition featured a number of ethnic bands that strolled around not only the Streets of the World section, but also performed in other sections of the Expo. The development of the transport buses that were used at the Exposition was a joint effort between Cleveland's White Motors Corporation and the Greyhound Corporation. Automotive transportation was a developing phenomenon in 1930s cities, and the Greyhound Corporation was experimenting with products that could be developed to replace the streetcars that at that time dominated city transportation. Just inside the left entryway is the pennant-topped façade of Schmidt's Rathskeller drinking hall and restaurant. (Author's collection.)

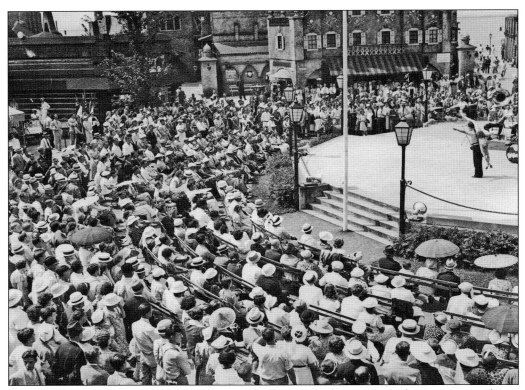

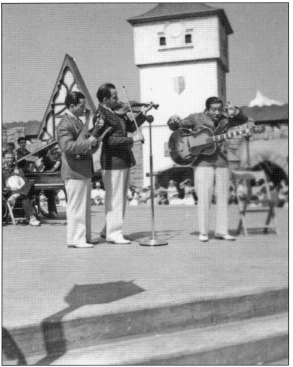

Performances at the International Stage continued almost nonstop throughout the day and, as can be seen above, were well attended. Some performing groups gained almost cult followings among Exposition workers and vendors. Toward the end of the first summer, some of these performing groups were honored with their own special days, when the groups were feted with accolades and gifts, sometimes provided by Exposition organizers. The SOTW's International Stage featured a wide variety of music, dance, acrobatics, drill teams, jugglers, and ethnic performances. At left, an Italian string trio performs an expressive piece on a lute, a violin, and an acoustic guitar while the Belgian Wooden Shoe Dancers and their musicians await their turn behind them. Schmidt's Rathskeller drinking hall and restaurant was located in the white building in the background. (Above, CMP; left, author's collection.)

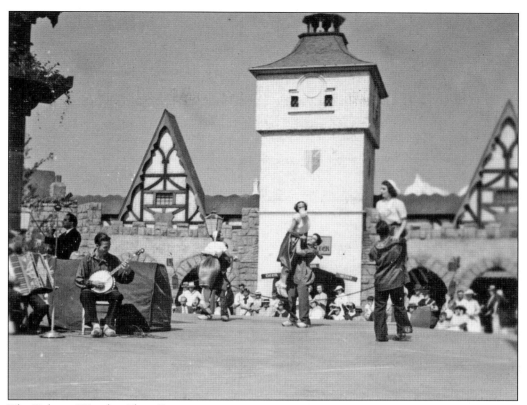

The Belgian Wooden Shoe Dancers were one of the most-loved groups that performed on the International Stage. The group's energetic afternoon performances of their twirling dances showed off their colorful costumes and spectacular lifts, all accompanied by their whooping yells and the clopping sounds of their wooden shoes. The group is being accompanied by musicians playing an accordion and a banjo. The building behind them housed Schmidt's Rathskeller, which featured beer, liquor, and wine. Visible farther to the east is the Matterhorn feature that was part of the Alpine Village. The image to the right shows people listening to a musical performance on the International Stage while others mill about. Behind them is Schmidt's Rathskeller, the central wooden pole of the International Stage, and in the distance, the white façade of the French Casino and the pagoda roof of the entrance to the Asian Village. (Both, author's collection.)

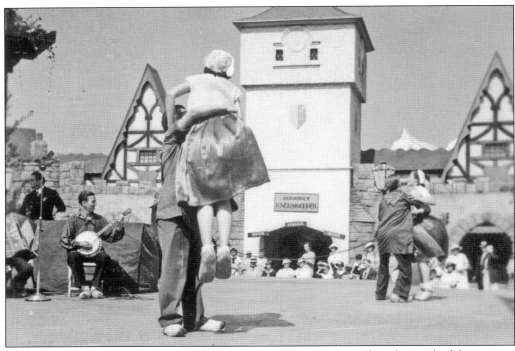

These two images show the Belgian Wooden Shoe Dancers dressed in their colorful costumes and performing their popular dance routine that featured twirls and lifts. Above, the dancers are caught mid-lift while their accompanists play banjo, accordion, and piano behind them. Behind them in the distance, Schmidt's Rathskeller advertises beer, liquor, and wine while some members of the audience use their hands to shade their eyes from the midday sun. Below, the couple in the foreground is caught in the middle of letting out one of their whooping calls. This image also shows the planter column that was in the middle of the International Stage and Schmidt's Rathskeller to the right. The International Stage's central wooden pole featured planter shelves and was topped by a large carved wooden box. The street that led to the French Village is to the left, and at the end of the street, the façade of the Waldorf French Casino can be seen. (Both, author's collection.)

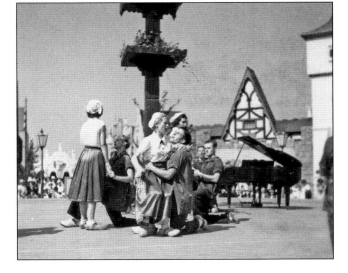

96

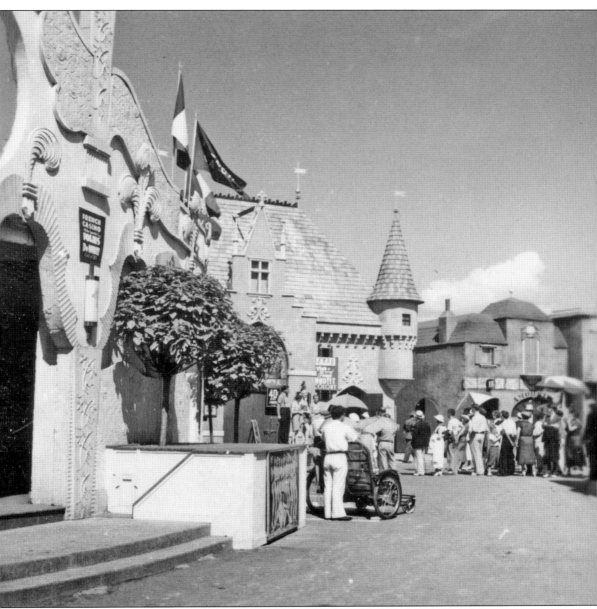

There is a lot to be seen in this photograph of the French Village. At left, the Palais de Nuit sign can be seen to the right of the doorway to the French Casino. A closer look reveals a depiction of a line of naked women on the front of the barker's stand in front of the two small trees. Farther to the right, a barker stands next to three of the attraction's models who are dressed in towel-like wraps and tells the crowd about what they will see if they pay their admission fee—40¢ after 4:00 p.m. What people saw if they entered the Little French Nudist Colony were actually very little nudists. Patrons looked through peepholes and saw nude dancing girls who appeared to be only a few inches high, because their images were being viewed through a series of mirrors. At the far right is the Amourita, another attraction that featured nudity. (Author's collection.)

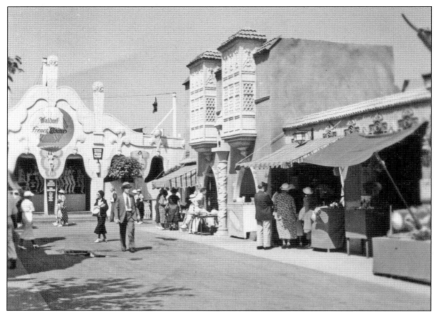

The image above is a closer view down the street that housed the French Village. People can be seen at far right checking out the goods at a French bazaar, and just to the left is a food stand that appears to be selling corn on the cob. It is not hard to tell what is being sold at the French Casino, as pictures of nude women can be seen over the entrance and to the right of the tree, and just inside the entrance is a mural that features a tightly packed row of nude dancing girls. Below, a crowd gathers in front of the Little French Nudist Colony while the Goodyear blimp *Reliance* flies overhead. Also visible are the Amourita next door to the Nudist Colony and the Keyhole attraction to its right. Interesting in this image are the man in the suit at far left and the boy in the striped shirt and shorts, both assuming the same arms akimbo pose. (Both, author's collection.)

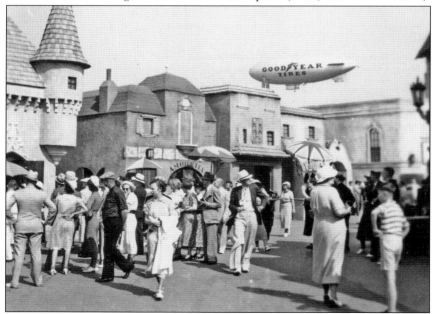

At right is a photograph of the Little French Nudist Colony, where a tall barker and three of the attraction's performers stand uncomfortably on a narrow platform, trying to draw people in to their "Nudist Colony from Gay Paree." It is hard to tell exactly what is going on in the photograph below of three of the Nudist Colony's performers and their talker standing on a platform under an umbrella. The three young women are dressed in what appear to be sheets, and the woman in the center is blindfolded as she holds a pair of sunglasses in her hand. This would be seen as exploitation today, but in the 1930s, it was considered entertainment. (Both, author's collection.)

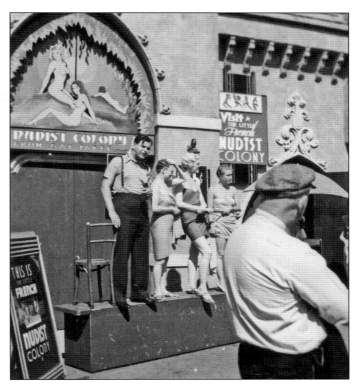

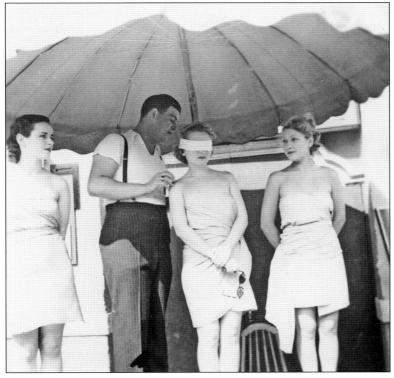

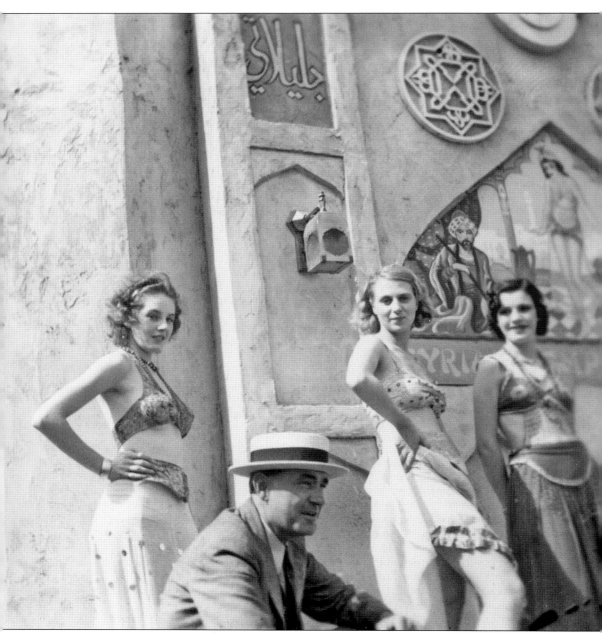

These performers at the Syrian Temple of Dance look like dancers, but they do not look Syrian. The mural above the entrance gives fairgoers an idea of what they might experience within. The photographer took more than one picture of these dancers and must have had an ongoing interaction with them, as in at least one of his images, the barker is scowling at him. In this photograph, two of the dancers are looking directly at him and striking provocative poses. The Exposition organizers—and from time to time, the Cleveland Police—tried to control the display of nudity at the Exposition by limiting the number of posters and murals that displayed nude images and by cracking down when it was discovered that some of the performers were underage. (Author's collection.)

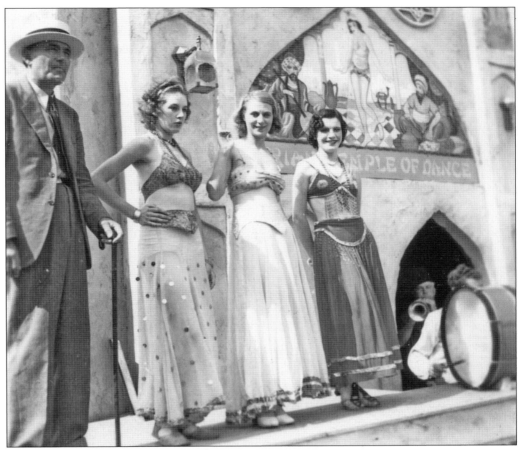

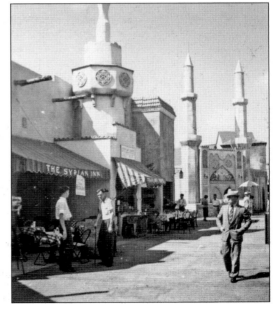

Above, it appears that the photographer has gotten the attention of one of the Syrian Temple dancers, as she is waving at him, while another looks on and smiles. In 1936, it was still an oddity to be walking around with a camera, so if someone had one, they would be obvious in a crowd. It is quite possible that the photographer was making a pest of himself and trying to get a reaction out of the dancers. The photograph to the right shows the buildings to the left of the Syrian Temple of Dance. Note that the dancers and their barker have left their platform and are probably performing inside the building. The Syrian Inn is providing outdoor seating to the far left, and between the inn and the temple is the Syrian Gift Shoppe. It is unknown whether the corner establishment was an extension of the Syrian Inn or separate. (Both, author's collection.)

The SOTW section was not all about dancing girls and nudity; it also offered visitors opportunities to experience the crafts, art, and culture of nearly 40 of the world's countries. Expo visitors could take home a unique souvenir in the form of a photographic or drawn portrait. Today, almost everyone has the ability to use their phone to take high-quality photographs of others and themselves, but in the 1930s, it was still a rarity to be able to have your picture taken. This attraction in the SOTW section encouraged people to "Have Your Photo Taken While You Wait At The Streets of the World Studio." Below, a collection of artists on the Exposition's Marine Plaza work on completing portraits of Expo visitors. The seated artist certainly looks the part, dressed in a smock coat and beret. (Both, author's collection.)

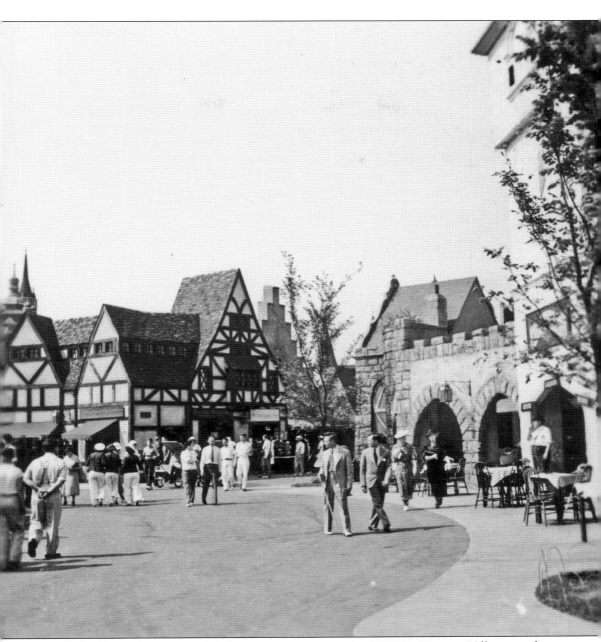

The buildings that surrounded the entrance street to the SOTW's German Village are shown here; Schmidt's Rathskeller's open-air dining facility can be seen to the right, and a sign advertises a German candy shop in the timber-frame building to the left. Other interesting things are a group of three of the Exposition's Yeomanettes walking through International Circle (under the awning) and a young man pulling a rickshaw (just to the right of the Yeomanettes). The Exposition's single- and multi-seat rickshaws were pulled around the grounds by college students and were a popular form of transportation. (Author's collection.)

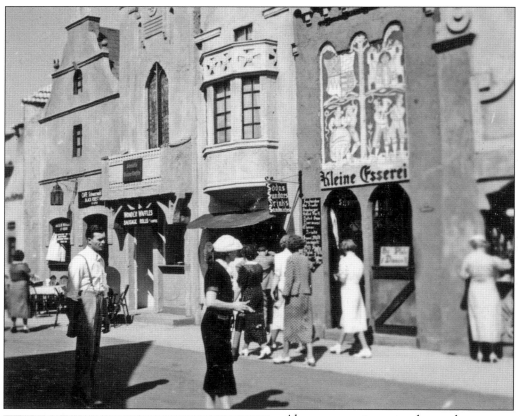

Above, a man in suspenders and a woman in a white hat have stopped to look at the food offerings of the Kleine Esserei (little eatery) in the SOTW's German Village section. Their offerings included franks, hamburgers, pork, liverwurst, and cheese sandwiches. One door to the west is Schmidt's Wonder Waffles, which sold sausage rolls and coffee, and next to that was the Cafe Schwartzwald, a Black Forest Grille that featured six-percent alcohol beer. The SOTW's villages were structured to immerse visitors in a particular architectural style to give them the impression that they had been transported into a different part of the world. The image to the left offers a look inside a German beer hall, where a man in a campaign hat and a mysterious-looking man in spectacles listen to a male singer in a gaudy plaid suit who is accompanied by a pianist and drummer dressed in lederhosen. (Both, author's collection.)

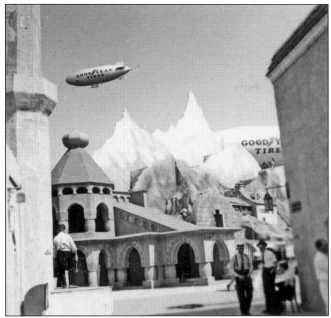

A Spanish villa in the Alpine Village is featured above. It was the opinion of many that the Great Lakes Exposition's Streets of the World did the best job of recreating authentic-looking foreign lands. In the background is the Matterhorn feature, which both served as a backdrop to the Streets of the World section and as a directional landmark. The image below shows a crowd of people and the Goodyear blimp *Reliance* lifting off from the blimp field behind the Matterhorn. The Exposition featured a number of performers who entertained visitors as they waited in line to enter attractions. With the combination of strolling bands, souvenir hawkers, and amplified barkers, the Great Lakes Exposition was no doubt a very noisy place. (Both, author's collection.)

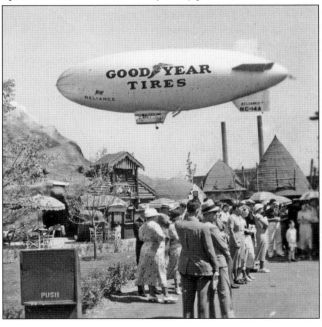

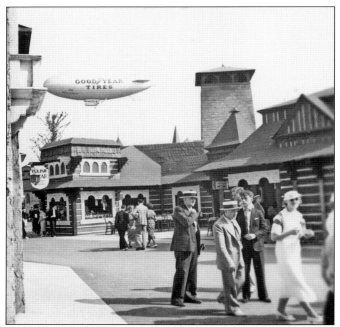

The SOTW's Polish Village occupied one of its largest spaces. The SOTW's building designer, Richard Rychtarik, based his Polish Village design on a recreation of a public square in Krakow, Poland. One of the village's buildings was the twin towers of Krakow's St. Mary's Cathedral, one of which can be seen above to the right. To the left of the spire, a black sign advertises a Gypsy restaurant called the Romany Rest Tea Room. The main draw of the Tea Room was having tea leaves read by a Gypsy fortuneteller. Below, Goodyear's *Reliance* blimp flies over the Polish Village's Polish bazaar. Two of Richard Rychtarik's favorite construction motifs were the log-building façade, seen here, and the timber-frame façade. (Both, author's collection.)

Both of the towers of the reproduction of St. Mary's Cathedral can be seen in the photograph at right, taken inside the SOTW's Polish Village. Visible to the right of the towers is the Morskie Oko restaurant, named after Poland's Morskie Oko Lake region. To the right of the restaurant is a Polish fortuneteller's shop, with a Polish falcon symbol above its entrance. Exposition visitors could choose from more than a dozen fortunetellers to read tea leaves, cards, and palms. The photograph below provides a closer view of the outside of the Morskie Oko restaurant and the sign, which advertises beer, wine, and sandwiches in both Polish and English. (Both, author's collection.)

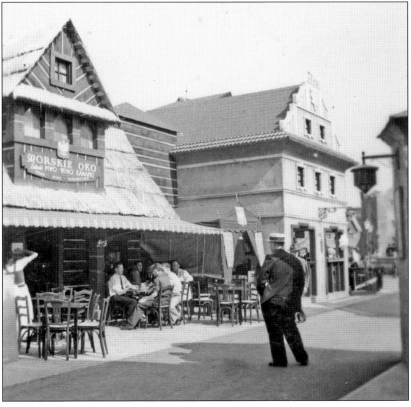

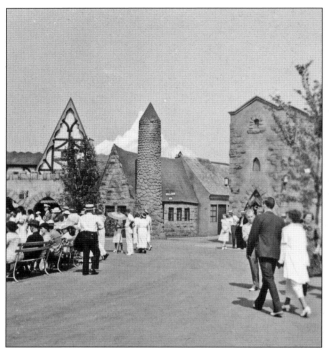

The photograph to the left shows the entrance to the British Village, off the International Circle, just to the right of Schmidt's Rathskeller. The stone structure on the corner housed the Isle of Erin Gift Shop, and the building across the street from it housed an ice cream shop. The British Village included a combination of stone buildings and quaint thatch- and tiled-roofed cottages. The photograph below shows the British Village's Cottage Lane. This collection of quaint English cottages housed craft shops, souvenir stands, restaurants, and gift shops. Three groups of people sit at tables in a British restaurant that is featuring fish and chips dinners as well as tea and pastries. (Both, author's collection.)

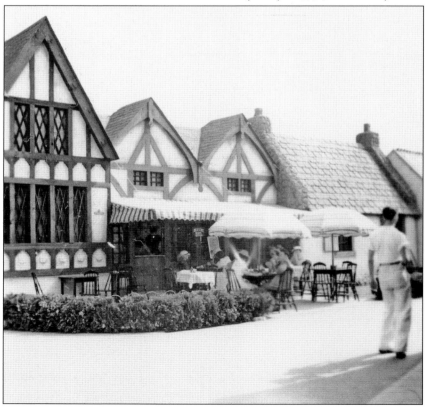

The view of a shop in the SOTW section to the right was taken from inside one of the Exposition's many outdoor cafes. The only word on the shop's over-the-door sign that is decipherable is "Shoppe," but the style of the structure indicates that it might be on the British-themed Cottage Lane, or possibly in the German Village section. The view below looks out from just inside the British Village toward the International Stage, and farther out to Schmidt's Rathskeller. Based on the shadows in the photograph, it appears to be midday, and the International Stage's performers are probably on their lunch break. Also seen are the International Stage's center pole, and the Matterhorn feature from the Alpine Village, visible behind the Rathskeller building. (Both, author's collection.)

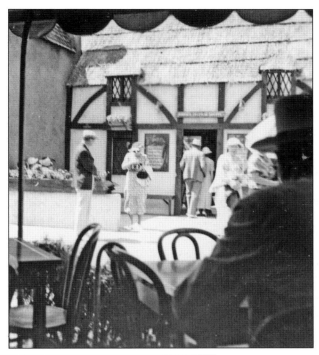

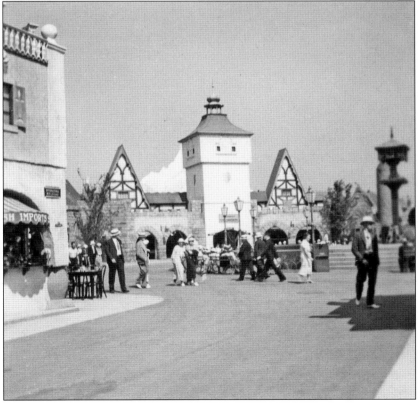

The photograph above shows the Sweden House in the Scandinavian Village section of the SOTW, which was next to the Norway House (to the left). The Sweden House sold craft goods, contained displays of Sweden's history, and offered a small restaurant that served coffee and doughnuts, shown here to the left. The photograph below is of a coffee shop—or in this image, a "Koffistood"—in the SOTW's Scandinavian Village section, next to the Norway Building. The American flag in the International Circle can be seen over the roofline of the Norway Building at left. (Both, author's collection.)

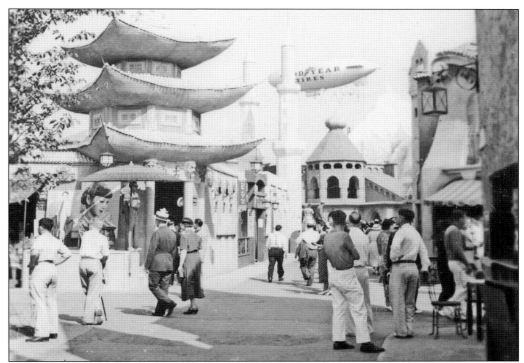

Above, a large crowd has gathered to listen to a barker talk about the two Asian women who stand beside him on an elevated platform. To the right, Chinese hats, slippers, and lamps are for sale in an Asian bazaar. As seen below, the Far East was depicted in the Chinese Village as an exotic avenue in the SOTW section. In the distance, the Matterhorn feature from the Alpine Village is barely visible beneath a Goodyear blimp that soars above it. In 1936 and 1937, the Chinese Village was very popular with fairgoers. (Both, author's collection.)

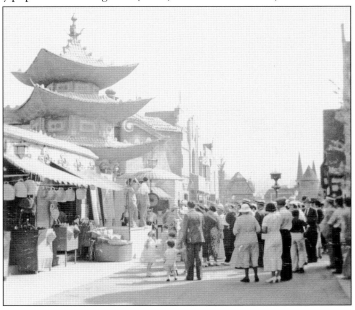

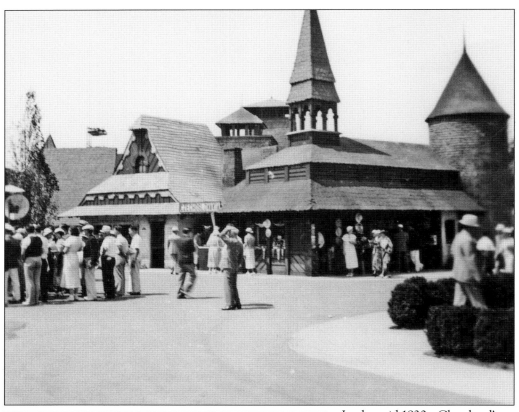

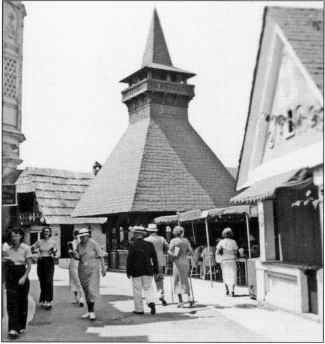

In the mid-1930s, Cleveland's Czech population was its largest ethnic group, followed by its Polish population. The image above shows the Czechoslovakia exhibit in the SOTW section. The Czech exhibit fell short of its designer's expectations, and instead of containing shops that featured and sold authentic Czech goods and foods, it instead offered mostly non-Czech items. Cleveland also had a large Hungarian population, and the Exposition's Hungarian Village was thought by some to be the SOTW's most authentic. Pictured at left is the Hungaria restaurant, on the right, sitting between an impressive sloped-roofed building to the left and a Hungarian cottage to the right. (Both, author's collection.)

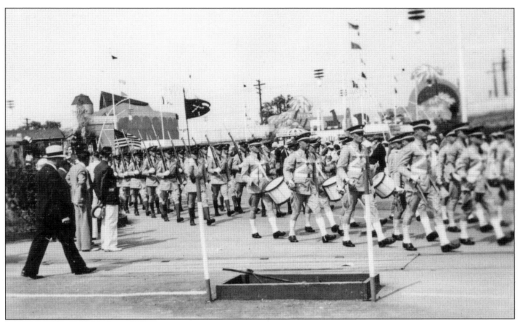

Company C of the 11th Infantry of the US Army, stationed at Fort Benjamin Harrison, was encamped in the southeast section of the Exposition's Amusement section near the blimp field, just south of the SOTW section. The company of soldiers participated in official ceremonies throughout the Expo's run and gave demonstrations of military maneuvers and equipment. In this photograph, the company is on parade along the Midway, preceded by their military band. Below, members of the 11th Infantry stand in front of a row of military vehicles that were produced by the White Motors Corporation. The soldiers appear to be "at rest" as two young boys run and play in the street in front of them. (Both, author's collection.)

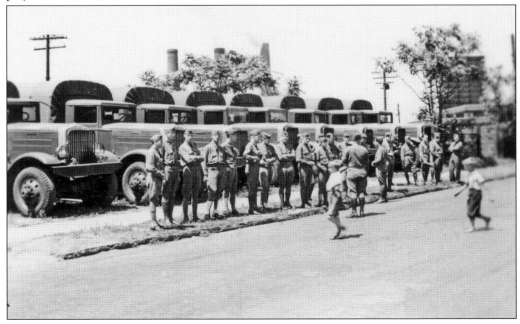

Throughout the Expo's two summers, as many as four Goodyear blimps were moored at the Goodyear blimp grounds at the far eastern end of the Exposition grounds. In addition to being directly adjacent to the Expo's Streets of the World section, the blimp grounds were also next to the US Army's military encampment. For $3 (nearly $50 in today's money) per person, Exposition visitors could take a ride over the Expo grounds, the Lake Erie shoreline, and downtown Cleveland. Above, the Goodyear blimps *Reliance* and *Puritan* are seen taking off or landing at the blimp grounds, just beyond the Matterhorn feature within the Alpine Village section of Streets of the World. At left, the *Puritan* is flying over the entrance to the Streets of the World. (Both, author's collection.)

Six

A GRAND REBIRTH

SIGHTS TO BE SEEN AT THE GREAT LAKES EXPOSITION.

This advertising postcard for the Expo's 1937 season captures the astounding variety of "Sights to be Seen at the Great Lakes Exposition." The features of the Expo pictured on the poster include (from top to bottom) Goodyear blimp rides, fireworks displays, dancing girls, diving exhibitions, the Midway, the Horticulture Building, the use of rickshaws for the transportation of visitors, figure-skating exhibitions, the Showboat floating entertainment venue, and the Streets of the World. (CMP.)

Great Lakes Exposition executives are seen riding in a parade on the Expo's opening day in June 1937. From left to right are (front seat) unidentified; Lincoln G. Dickey, general manager of—and driving force behind—the Great Lakes Exposition; and unidentified; (back seat) Dudley Blossom, chairman of the Exposition; Lenox R. Lohr, general manager of the Exposition's Century of Progress exhibit (which was resurrected from Chicago's 1933 A Century of Progress World's Fair) and president of the National Broadcasting Company; and W.T. Holliday, president of the Standard Oil Company of Ohio and the 1937 Great Lakes Exposition. (CMP.)

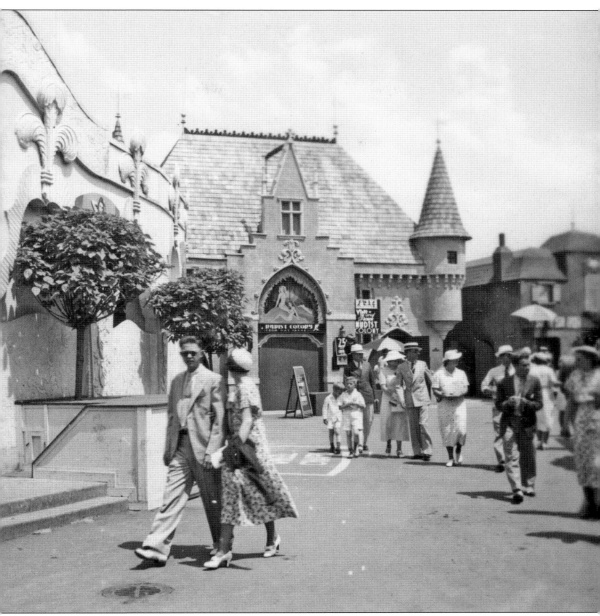

Originally, the Expo was scheduled to last for 100 days, but just before it closed on Columbus Day, after a 10-day extension, Exposition organizers decided to "winter-over" the Expo's buildings and features and reopen them for a second summer in 1937. Due to lower-than-expected attendance during the first year—the summer of 1936 was unusually hot, nudity kept many families away, and many of the Expo's attractions were not spectacular enough to bring back repeat business—the Exposition did not earn as much profit as was hoped, and Expo organizers were unable to pay back their investors. The plan for the second summer was to hire better acts and rid the Exposition's attractions, like the ones shown here, of naked women. It was hoped that these changes would bring in the families that did not show up in 1936 and that the Exposition's investors could be paid back in full. (Author's collection.)

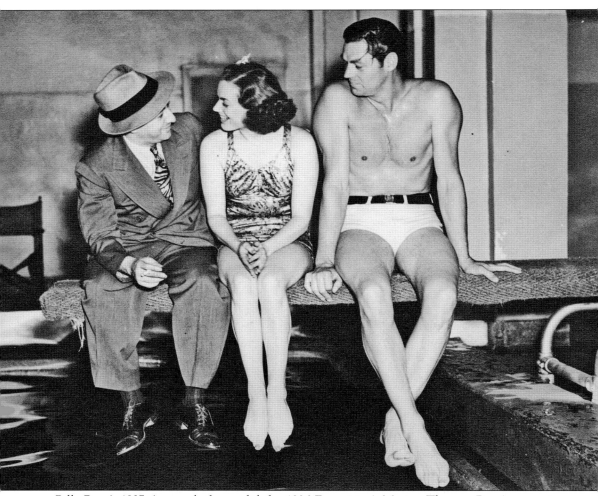

Billy Rose's 1937 Aquacade far outdid the 1936 Exposition's Marine Theatre. Rose's attraction included a 5,000-seat lakeside theater and a restaurant that sat 2,000 diners on terraces that overlooked the Aquacade's swimming area and stage. The Exposition's second-year improvements were financed with an additional $500,000 from investors, which was raised in only seven days. While the admission to the 1936 Expo's Marine Theatre was free (unless visitors wanted to pay 50¢ to sit in the reserved section), admission to Billy Rose's Aquacade was $1 to $1.50, depending on where one sat. The Aquacade was a swimming, diving, dance, and theater extravaganza, featuring Olympians Eleanor Holm and Johnny Weismuller, who was the star of *Tarzan* movies of the 1930s. From left to right, Billy Rose, Eleanor Holm, and Johnny Weismuller are sitting on a diving board at the Aquacade's pool. A scandal erupted during the 1937 Exposition, when Rose left his wife, movie actress Fanny Brice, for Holm, who he would marry a few years later. (CMP.)

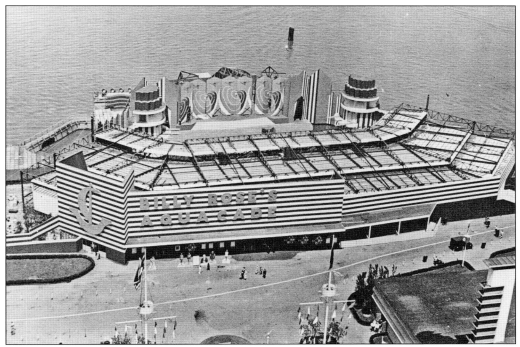

Billy Rose's Aquacade presented a variety of famous dance bands, including Wayne King, Ted Weems, Shep Fields, Isham Jones, and Glen Gray. Exhibitions by world-famous Olympic divers and swimmers and a show that featured mermaids, special effects, and innovative lighting combined to present a spectacular water show on a large floating stage. The Aquacade's theater-restaurant seated 5,000 and featured performances by Olympic champion swimmers Eleanor Holm and Johnny Weissmuller along with diving and synchronized swimming shows. Cleveland's Aquacade was so popular that it was continued at the New York World's Fair a few years later. (Both, CMP.)

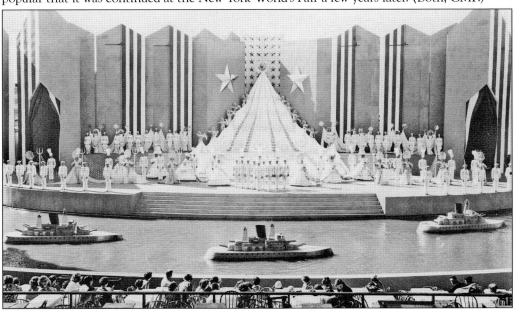

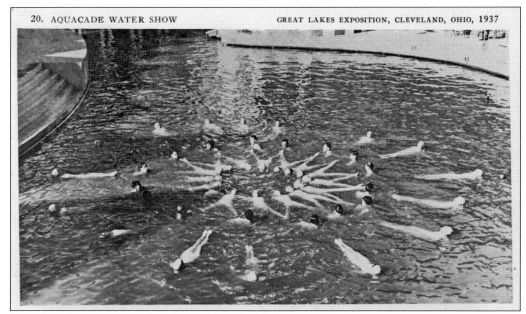

The offerings of Billy Rose's Aquacade were more professional and sophisticated. The show offered professional swimmers and divers and, as seen above, included synchronized swimming exhibitions. Reports from swimmers were similar to the views expressed by the Marine Theatre's amateur swimmers in 1936: the waves were high, and the water was cold and dirty. The photograph below was taken during a performance at the 1937 Exposition's Winterfair. Winterfair was an ice-skating extravaganza that featured patriotic and historical themes. Winterfair was far ahead of its times, predating professional ice-skating shows like the Ice Capades by many decades. (Both, CMP.)

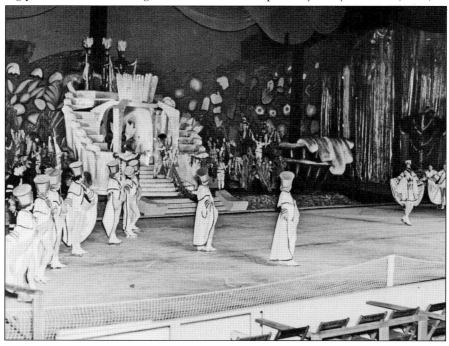

This photograph shows a large crowd gathered on the Exposition's 1937 Marine Plaza outside the entrance to the Winterfair attraction. As was the case during the summer of 1936, dress at the Exposition was formal by today's standards. Notice the woman in the fur coat toward the bottom right. Visible in the rear are, from left to right, the entrances to the Exposition's Midway and Streets of the World, the Higbee exhibit, and the Florida exhibit. The idea of staging the Winterfair exhibit in the summer of 1937 was partially motivated by the extreme heat that plagued the Exposition's 1936 season. As can be seen here, Exposition attendees were still almost universally white, and very few parents brought their children. (CMP.)

There were other major changes in attractions and uses of buildings between the 1936 and 1937 seasons. With the move of the main entrance from St. Clair Avenue to Lakeside Avenue, the Sherwin-Williams Plaza and Public Hall were no longer within the Exposition's footprint. In addition, the Porcelain Enamel Building was dismantled, and the "Parade of the Years" show was not reengaged; its spot was replaced by Winterfair. Finally, the Showboat's nightclubs were removed from the *Cleaveland* and relocated on the top two floors of the Horticulture Building. The space on the *Cleaveland* was taken over by the expansion of Herman Pirchner's restaurant business, with the opening of Herman Pirchner's Showboat. Other 1937 changes included the opening of Billy Rose's Pioneer Palace in the building that housed the Little French Nudist Colony in 1936, the Globe Theater reproduction featured a marionette show instead of Shakespearean plays, and the more wholesome *Ripley's Believe It or Not!* replaced John Hix's *Strange as It Seems.* This is an advertisement for Pirchner's Exposition offerings. (CMP.)

Seven

A GRAND LEGACY

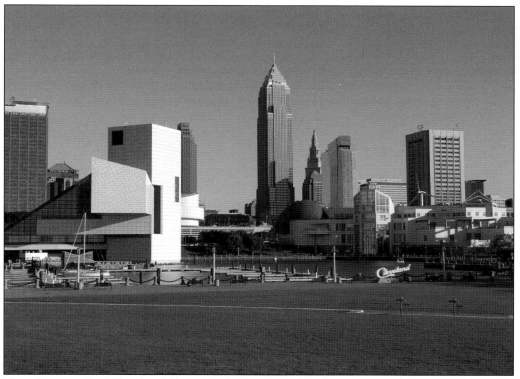

This photograph of Cleveland's Lake Erie harbor was taken from Voinovich Park on Cleveland's lakefront. It shows how far the development of the lakefront has come from its pre-Exposition shanty-filled wasteland to its present vital state. The land that was occupied by the Great Lakes Exposition's Marine Plaza and Midway are now home to (from left to right) the Rock and Roll Hall of Fame and Museum and the Great Lakes Science Center. (Jamie Janos.)

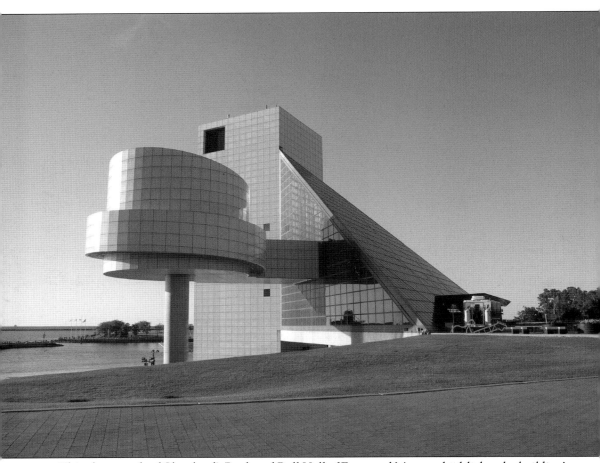

This photograph of Cleveland's Rock and Roll Hall of Fame and Museum highlights the building's striking lines and forms built around basic geometric shapes. The building was designed by famed architect I.M. Pei. Located in North Coast Harbor, the Rock and Roll Hall of Fame and Museum honors influential artists and industry figures who were important to the development of rock-and-roll music. Cleveland was chosen by a development foundation to be the location of the institution in 1986, and the building was completed and the attraction opened in 1995. The City of Cleveland pledged $65 million to fund the cost of the hall's development and construction. Each year, the hall inducts a set of rock-and-roll luminaries, and its museum houses artifacts that trace the history of rock and roll. The hall's inductees are honored in an exhibit space that hangs over Lake Erie. (Jamie Janos.)

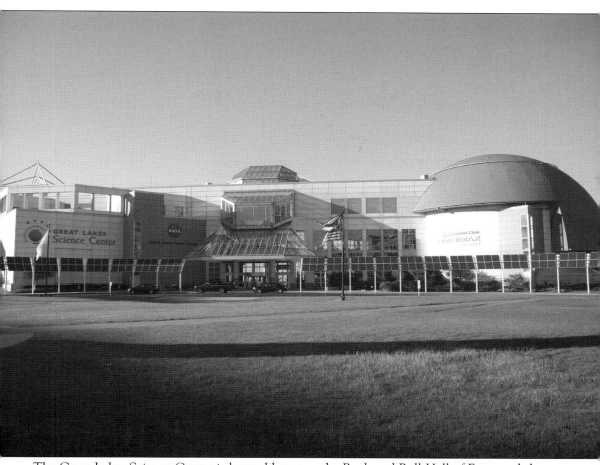

The Great Lakes Science Center is located between the Rock and Roll Hall of Fame and the Cleveland Browns' FirstEnergy Stadium in North Coast Harbor. The center serves as a museum and educational center, highlighting hands-on displays that provide information about the Great Lakes region's natural environment. The center works closely with local school systems to offer programs that augment their curricula. The center's displays include the NASA Glenn Visitor Center, an OMNIMAX theater, the *William G. Mather* steamship, a science academy, and a STEM-oriented high school. (Jamie Janos.)

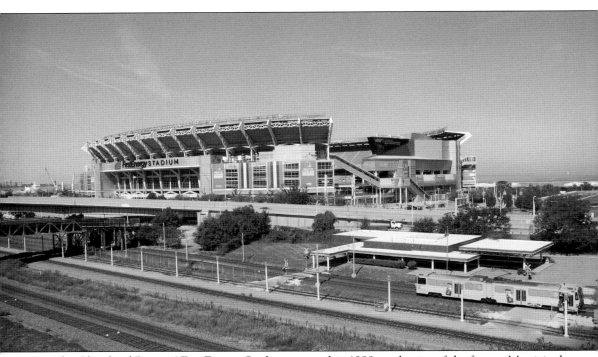

The Cleveland Browns' FirstEnergy Stadium opened in 1999 on the site of the former Municipal Stadium. Portions of the Municipal Stadium structure were relocated to Lake Erie and serve as an artificial reef. FirstEnergy Stadium was built as part of a deal to reactivate the Cleveland Browns football team after it was relocated to Baltimore and renamed the Ravens. The stadium is a concrete and glass structure designed by the firm of Hellmuth, Obata + Kassabaum. It features a natural grass field heated by 40 miles of underground piping. (Jamie Janos.)

Daniel Burnham's 1903 Group Plan for Cleveland called for the development of a downtown mall surrounded by Neoclassical civic buildings. Development was delayed multiple times throughout the 1900s by two world wars, the Great Depression, and a lack of investment in Cleveland's downtown core. After a century of development, the Great Mall is considered to be one of the finest examples of the City Beautiful movement, and it was listed in the National Register of Historic Places in 1975. Conspicuous in this photograph are the War Memorial Fountain and the Mall's three open celebratory sections. Plans are currently being developed to construct a 900-foot-long pedestrian bridge that will stretch from the northern end of the Mall to an open area between the Rock and Roll Hall of Fame and the Great Lakes Science Center that, for the first time since the Great Lakes Exposition, will provide an accessible link between Cleveland's downtown core and its vibrant lakefront. (Jamie Janos.)

Discover Thousands of Local History Books
Featuring Millions of Vintage Images

Arcadia Publishing, the leading local history publisher in the United States, is committed to making history accessible and meaningful through publishing books that celebrate and preserve the heritage of America's people and places.

Find more books like this at
www.arcadiapublishing.com

Search for your hometown history, your old stomping grounds, and even your favorite sports team.